THE DALÍ THEATRE-MUSEUM IN FIGUERES

ANTONI PITXOT
MONTSE AGUER
JORDI PUIG

TRIANGLE ▼ POSTALS

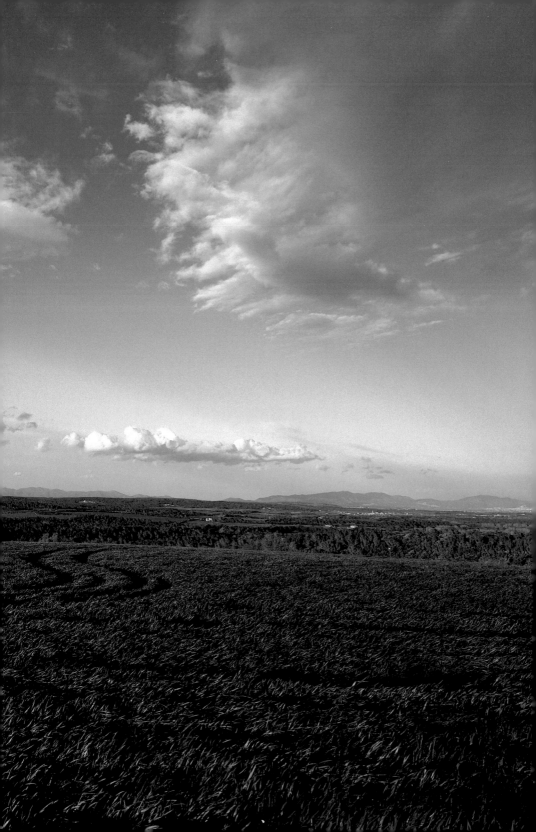

Figueres, with the church of Sant Pere and the cupola of the Dalí Theatre-Museum in the foreground.

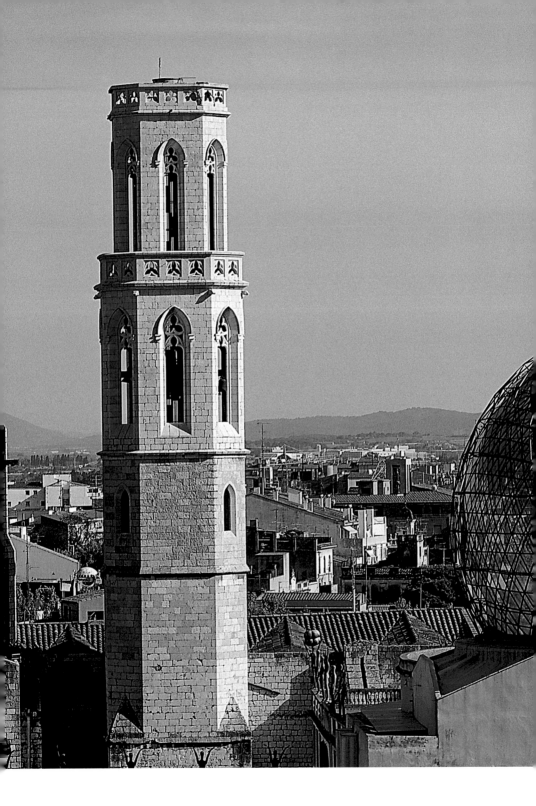

WHAT DO WE UNDERSTAND BY THE DALÍ THEATRE-MUSEUM?

A unique space: a museographical model created from an artist's specific conception to boost the semantic possibilities of his creative work; an outstanding work, arranged in a way that lays more emphasis on that which provides concepts and ideas over and above that which offers chronological historicism, and a distinct look: it is part of what we find and need in order to understand the Dalí Theatre-Museum in Figueres. Dalí, on creating this work of total art, this grand surrealist or *ready-made* project, as he himself described it on occasions, is distanced from fashionable trends and provides a space that is full of suggestions, confirmations and provocations that manage to awaken the interest of all the visitors-spectators.

This museum shapes the general structure of Dalinian creativity, projects an inner world and provides a tour of Salvador Dalí's artistic career and life, from the exhibitive approaches of surrealism and of the author himself. In this centre we can cover the evolution of Dalí's complete works: impressionist, futurist, cubist, pointillist and Fauvist canvases, until arriving at surrealism, to his classicist and nuclear-mystical period, the works related to the advances in science, and the last creations produced between 1980 and 1983, in which Dalí reappraises the grand classics, in particular Michelangelo and Velasquez. Here we discover a provocative, mystical, scenographic Dalí, impassioned by science and also, in a very clear way, the Dalí of the final period.

This centre cannot be understood without knowledge of the connection between the painter and the city where he was born and where he died, Figueres, and with the landscapes and idiosyncrasy of the Empordà region. There is, however, also an international projection in Dalí. He himself wrote that he wanted, "to make the Empordà region a universal place through the Dalí Theatre-Museum". Its landscapes, its settings, are important because they form part of his work. Salvador Dalí, the artist, the character, the man, would not be understood without the environment in which he lived.

"Everyone should consider the museum as a work of art in itself, like a text by Raymond Roussel, full of information, but totally devoid of exhaustive explanations. This means that everyone can make conclusions from what they see that are more consubstantially linked to their psychology and their cosmogony."

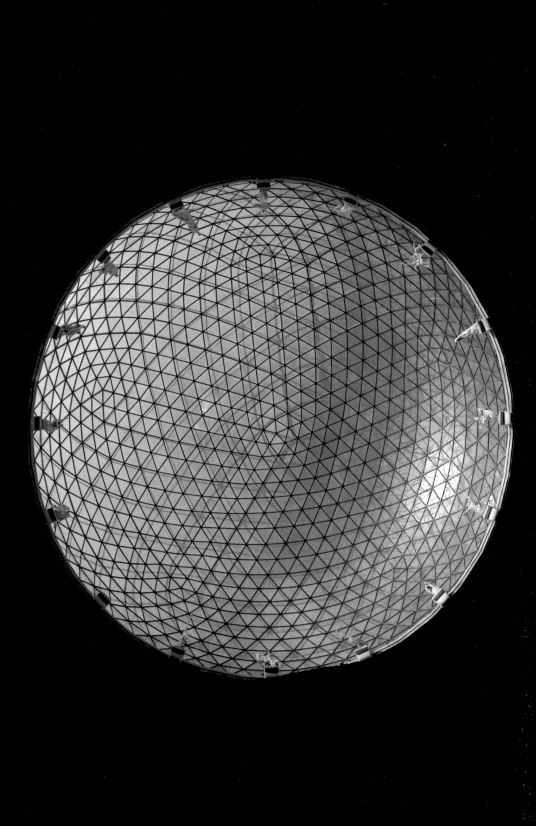

THE DALÍ
THEATRE-MUSEUM
IN FIGUERES

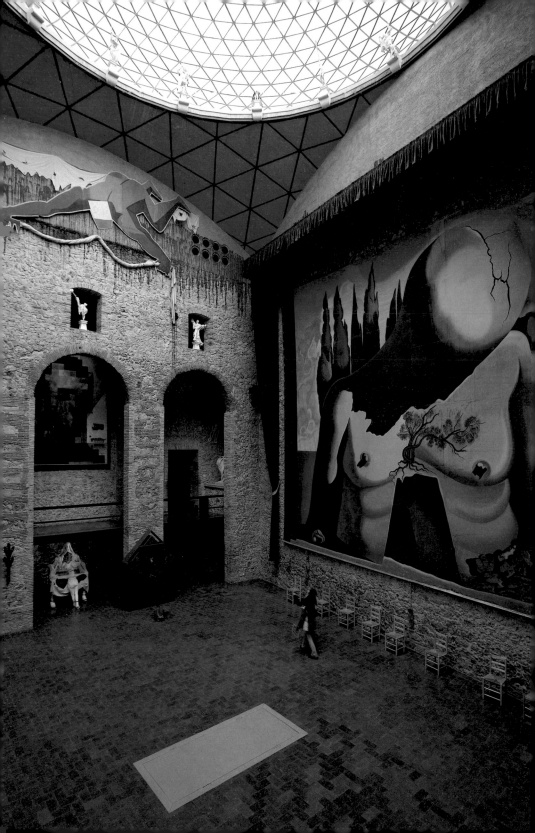

FOUNDING AND EVOLUTION OF THE DALÍ THEATRE-MUSEUM

In 1954, Salvador Dalí presented a «Mostra di quadri, disegni ed oreficerie» in the Caryatids Hall of the Royal Palace of Milan. This palace, the property of his friend Count Theo Rossi di Montelera, had been bombed and inspired Dalí to begin thinking about the burnt walls of the Municipal Theatre in Figueres, his birthplace, and an exhibition centre for his work. On the 8th of August 1961 Dalí announced in Figueres his desire to build a museum, and said the following: "Since I was very young my motto has been that of Mr Montaigne when he said that the only way of becoming universal is by means of the ultra-local (...) The theatre is a predestined spot for the Dalí Museum. I had the first exhibition of my life here. Every centimetre of these half-rotten walls is an abstract painting".

In October 1960, Ramon Guardiola Rovira was appointed Mayor of Figueres and asked the painter for the donation of a painting for the local museum, the Museum of Empordà in Figueres. The request was made again, by the Mayor, through the photographer and common friend Melitó Casals "Meli", and Dalí replied that not only would he donate a work to his birthplace, he would in fact donate an entire museum.

The process of creating the Theatre-Museum began in 1961. On the 12th of August the city paid homage to him, with numerous events, among which we can highlight a bullfight, the poster for which Dalí produced with the drawing of a bull rising, since he wanted a helicopter to carry the bull off once it had been killed, but the strong Tramontana wind that blew that day made it impossible. The painter's involvement did not end here and he entrusted the artists Niki de Saint Phalle and Jean Tinguely to make a plaster bull that exploded at the end of the bullfight, followed by a firework display. Later, he was presented with the "Fig-leaf", the highest honour awarded by the City Council and in the early evening, at half-past eight, in the still destroyed Municipal Theatre, he announced the ideas he had for this space, a predestined spot, according to him, because here he had presented his work publicly for the first time in an exhibition held in 1919. Along these lines, Dalí stated: "Where, if not in my city, must the most extravagant and solid of my work survive, where else? What remains of the Municipal Theatre seems highly suitable to me for three reasons: firstly because I am an eminently theatrical painter; secondly, because the Theatre is opposite the church where I was baptised, and you are fully aware that I am a Catholic, apostolic and Roman; and thirdly, because it was precisely in the vestibule room of the Theatre where I held my first painting exhibition".

"In fact we find here, skilfully placed, all the obsessions of the inventor of the critical-paranoiac method."

In 1964 the painter declared in Time magazine that his museum would begin with the installation of a reticular cupola by Richard Buckminster Fuller over the stage of the old theatre built between 1849 and 1850 by the architect Josep Roca i Bros. On the 29th of January 1968, through a council motion, it was agreed that the theatre be converted into the Dalí Museum. Finally, in 1969 the construction of the geodesic cupola was commissioned to the architect Emilio Pérez Piñero, the only one in Spain who made these kinds of structures. On the 1st of April 1970, at a press conference in the Gustave Mureau Museum in Paris, the artist once again announced the creation of the Dalí Museum in Figueres. On the 26th of June of the same year, the Cabinet passed the proposal for creating the Theatre-Museum. The building work was carried out thanks to the help of the Ministry of Housing and due to the fact that Figueres was considered a "devastated area" as a result of the bombings suffered during the Spanish Civil War.

On the 13th of October 1970, the pre-inauguration of the Theatre-Museum took place, in which Dalí showed the public the central canvas on the ceiling of the Palace of the Wind and exhibited the full sketch. The architect Joaquim Ros de Ramis, author of the Picasso Museum in Barcelona, directed the rehabilitation of the building along with the Figueres architect Alexandre Bonaterra. During August and September 1973, with a great deal of press coverage, the exhibition "Dalí, his art in jewels" was shown in the museum, in benefit of the Spanish Society of the Friends of Childhood. This show can be considered as a prelude to the official opening. Finally, on the 28th of September 1974, after many ups and downs, long procedures and waits, with the continuous support of the city and the mayor, and with the direct and active participation of the painter in its development, the tumultuous official opening of the Dalí Theatre-Museum was held. Ramon Guardiola, in the well-researched book *Dalí y su museo*, gives a description of the events on that day: "The museum was about to be opened. It was just too successful. It was organised chaos. The people responsible for public order really had to struggle. The overflow was inevitable (...) When Dalí and the authorities arrived at the Theatre-Museum, the Vice-President of the Government cut a tape and it was officially opened. From one new surprise to another, the admiration was general. Dalí went on explaining the details to those accompanying him. On reaching the old stage, beneath the cupola by Pérez Piñero, the maestro Ernesto Halffter conducted the performance of the Hymn of the Dalí Museum (...)".

The museum continued growing and expanding, like a living organism, since the artist introduced changes and additions until 1989, the year of his death. This centre represents his last great work and the culmination of a total work of art.

When, today, we speak of the Dalí Theatre-Museum we are referring to two very differentiated museum spaces: the first is made up of the old Municipal Theatre —a 19th-century construction designed by the architect Roca i Bros, burnt down by accident on the 19th of February 1939 by a group of soldiers from Franco's army recruited from Morocco— and converted into the Theatre-Museum based on the criteria and design of the painter himself. This collection of buildings forms a single artistic object where each element is an inseparable part of the whole, a creation by the artist that is maintained just as he conceived it; the second is the series of rooms that were progressively added to the original complex of the Municipal Theatre: from the crypt, since Dalí wanted to be buried underneath the cupola of his museum, through to the rooms belonging to Torre Galatea, a building purchased in 1981, which formed part of the old medieval walls of the city, where Dalí lived from October 1984 until his death, the 23rd of January 1989. Before moving in, the artist worked on the design of the façade and on the new shaping of the building. On the 9th of October 1983, he announced that, "from now on the Torre Gorgot will be known as Torre Galatea as a monument to all those enigmas". The tower, according to Dalí, would contain, "both the secret relics of the voyage of the Argonauts under the inscription 'Prohibited all those who are not heroes' and the Cavern of the

Enigmas". He also proposed that in other parts of the building the office of Francesc Pujols should be reconstructed, he used one room for projections with an inscription under the door that reads "Entry prohibited for art critics" and he studied the new scientific discoveries and aesthetics derived from the theories of the mathematician René Thom. He also produced the first sketches for the decoration of the façade of the Torre Galatea with the mannequins, eggs and croutons of bread.

On the 1st of July 1990 an extension of the Theatre-Museum was opened, in the same building where the artist had lived, a space that lays special emphasis on showing the works of his last period that goes from 1979 until 1983. On the 19th of May 1994, at an act presided over by Their Majesties the King and Queen of Spain, the so-called "new rooms" were officially opened, situated in an annexed building —what was once the Fonda Condal guest house and later an antique shop— where the latest acquisitions of the Fundació Gala-Salvador Dalí are shown, overlooked by the enormous canvas *Apotheosis of the Dollar,* (1965) **[C40]**. In June 1999 the foundation acquired the jewellery collection that had belonged to the North American Owen Cheatham Foundation, which had already been exhibited in the Dalí Theatre-Museum Dalí, in the artist's lifetime, during August and September 1973, one year before the museum was officially opened. This collection was shown in 2001 in the same space, which was redesigned for this purpose by the architect Oscar Tusquets to show the public both the jewels and the corresponding preparatory sketches, with the central presence, as in the new rooms, of the 1965 oil painting *Apotheosis of the Dollar.*

The Theatre-Museum as a whole represents the projection and realisation of the artist's dreams and creative energies. Just as Dalí himself explained: "It is clear that there are other worlds, it is certain: however, as I have said on many occasions, these other worlds are to be found within ours, they reside on earth and precisely in the centre of the cupola of the Dalí Museum, where the entire unsuspected and mysterious new world of surrealism is".

Another interesting view to be taken into account is that which Ignacio Gómez de Liaño provided when defining the Dalí Theatre-Museum: "...it became an authentic Theatre of Memory, like that projected in the Renaissance by the humanist and secretive Venetian Giulio Camillo (...) who, 'calls his Theatre', as Zuichemus told Erasmus, an endless list of names; since it is a mind built or constructed, and since it is a mind and soul with windows. He pretends that all things that the human mind can conceive and which we cannot see with the corporeal eye, after being collected together by diligent meditation may be expressed by certain corporeal signs in such a way that the beholder may at once perceive with his eye everything that is otherwise hidden in the depths of the human mind. And it is because of this corporeal looking that he calls it a theatre'". Gómez de Liaño continues: "The Theatre of Figueres —we could say of Figures— constitutes a system of mnemonic places, similar to what Giulio Camillo imagined to give the mind a face, of making evident that which is hidden, of opening windows to the soul, of making this a place of long-lasting consistency".

Each of the spaces and each of the works in the Theatre-Museum have a great attraction and, above all, give out a special sense of mystery. For this reason visitors still queue and will continue to queue captivated by this indescribable secret that is the attraction of genius. Dalí opens a door —a drawer— to us into the world, the world of the subconscious. We could conclude this introduction with the words that the artist addressed to Georges Bornes for *Le Figaro*: "If so many people visit it, thinks Salvador Dalí, it is because it is not a place where a series of paintings hang from the wall as in the majority of museums, but because it is full of enigmas. You know that the success of all religions lies in their mysteries. Once everything has been explained didactically, there are no longer any mysteries, and therefore no reason to return. In this museum, however, the people who have come once return the next day because that is the exasperated continuity of subjective knowledge!".

"I want my museum to be like a single block, a labyrinth, a great surrealist object. It will be a totally theatrical museum. The people who come to see it will leave with the sensation of having had a theatrical dream."

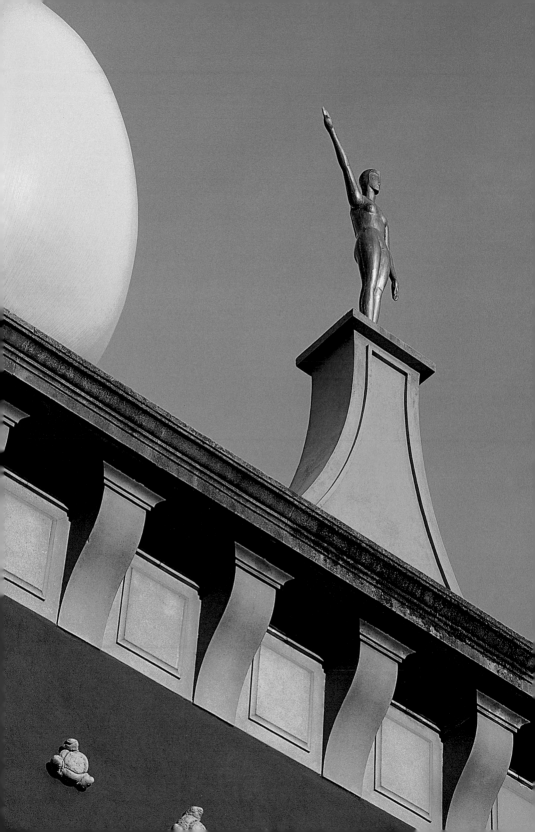

The Theatre-Museum represents the projection and realisation of the artist's dreams and creative energies. Salvador Dalí wanted the beginning of the Dalí Theatre-Museum, his crowning work, to be placed within the setting, especially the square called Gala-Salvador Dalí, the pavement of which converges in a radial design onto the stage of the museum, beneath the cupola where, by his final decision, he was buried. In the same way the painter wanted the pilgrim to his spiritual centre to begin in the visitors queue and in the leisure spaces around the Museum, from where one can begin the contemplative experience and get a glimpse of the presence of new visions, new concepts and thoughts.

In this introductory space, Dalí refers to some of his preferences and obsessions: science, with the *Homage to Newton*; academic art, with three sculptures by Meissonier; more innovative art, with *The TV-Obelisk* by Wolf Vostell; Catalan thought, with the monument to Francesc Pujols which also contains the figure of Ramon Llull.

OUTSIDE

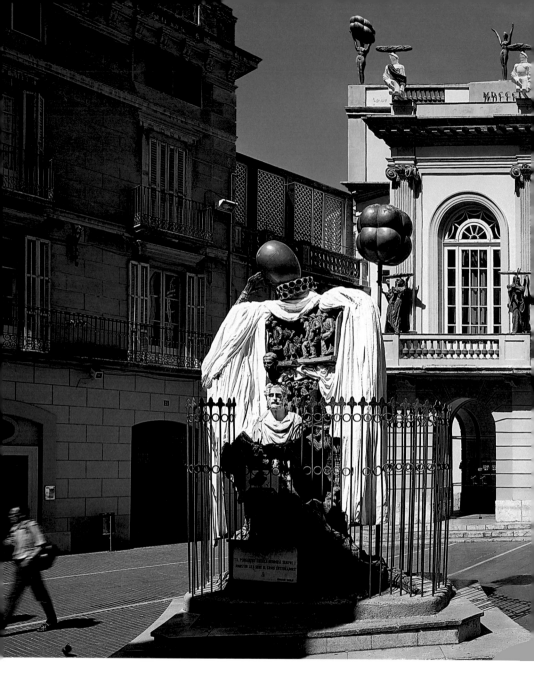

Plaça Gala-Salvador Dalí with the façade of the Theatre-Museum and the artist's monument to the Catalan philosopher Francesc Pujols.

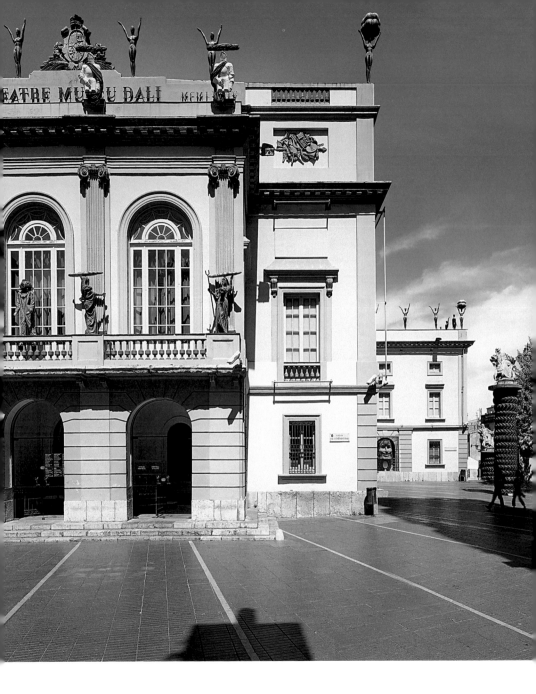

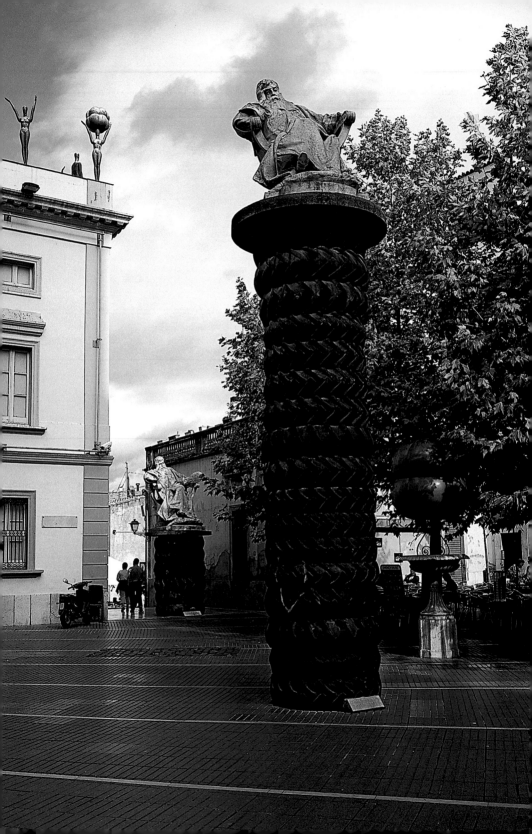

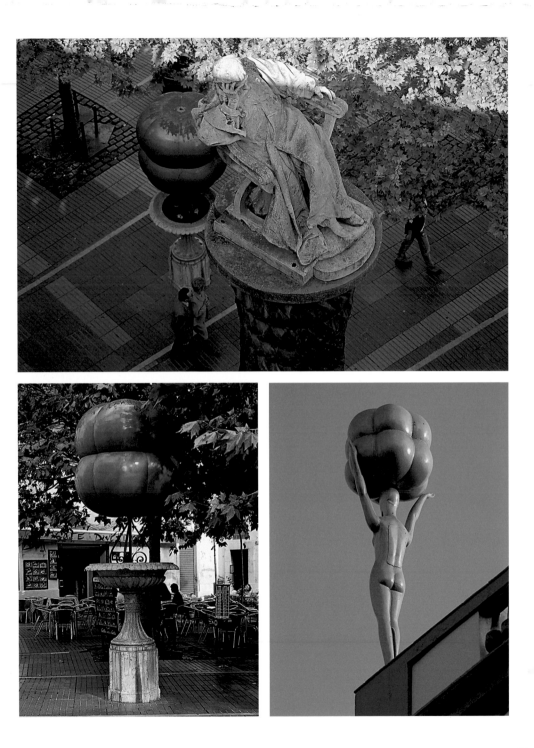

The hydrogen atom, a Dalinian iconographic motif.

← One of the three homages dedicated to the French painter Meissonier.

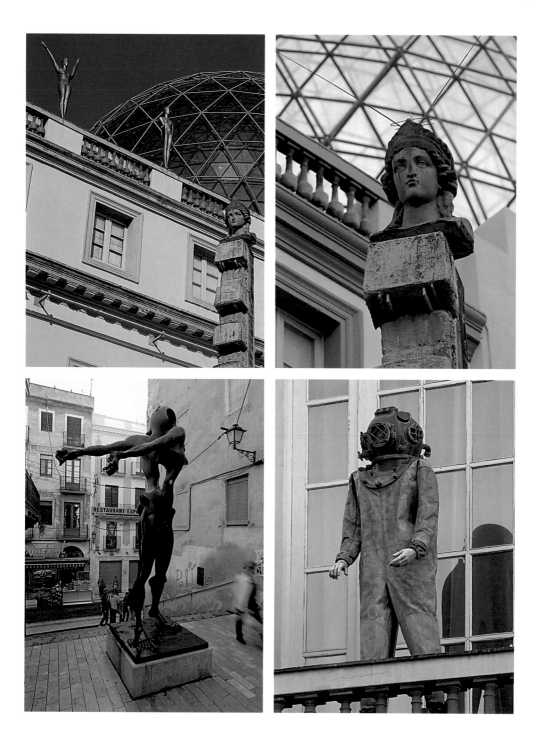

The *TV-Obelisk,* by Wolf Vostell.

Homage to Newton.

Diver with diving suit, a symbol of the immersion into the subconscious.

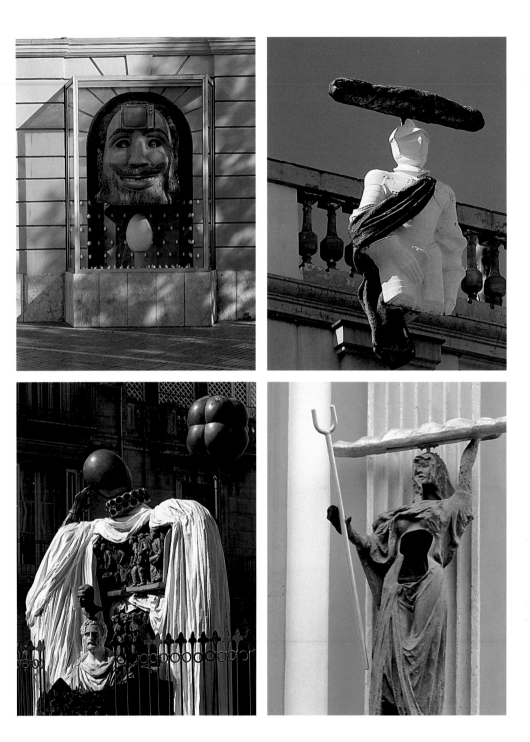

Dalinian installation with television at the front.
Warrior with a loaf of bread.
Monument to Pujols.
Figure with loaf of bread and crutch.

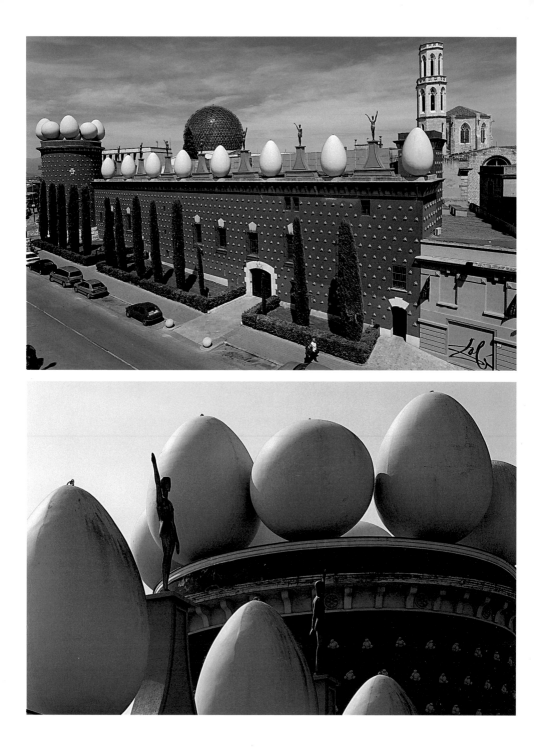

Torre Galatea, an annexed building of the Museum, named thus in honour of Gala.
Cupola and elements that crown the façade of Torre Galatea. →

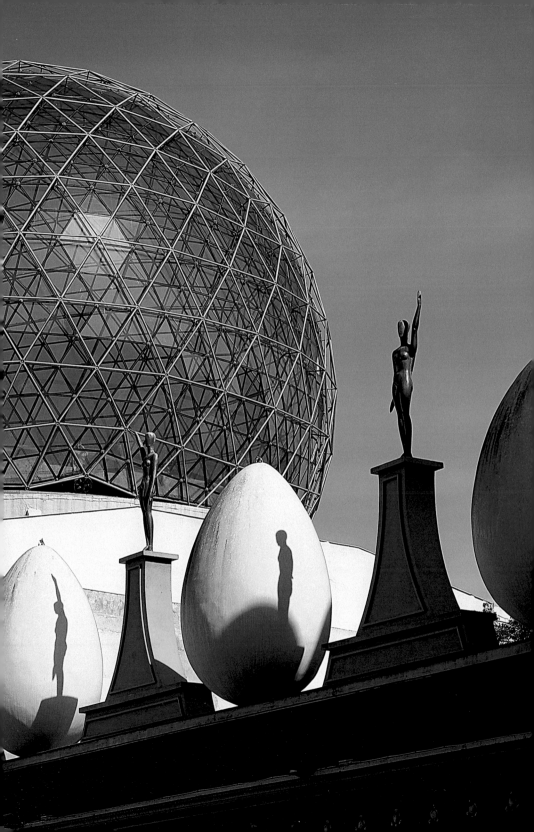

The Dalí Theatre-Museum, the old Municipal Theatre of Figueres, is situated beside the church of Sant Pere, where Dalí was baptised, something he liked to emphasise. Facing the main façade of the Museum stands the monument dedicated to the genius of Catalan, Francesc Pujols, a friend of the Dalí family for whose thought the painter showed a special interest. The monument, which at the base includes the philosopher's phrase, "Catalan thought always reappears and survives in its deluded gravediggers", is made from the roots of a hundred-year-old olive tree, with the body covered by a white Roman toga and crowned with a golden egg that shapes the head supported on a hand, in a similar pose to Rodin's *The Thinker*. The piece also has the marble bust of a Roman patrician with a small bronze head, in this case that of the selfsame Francesc Pujols, who reminded him of Pepito Pichot, another family friend. This front part also features three bas-reliefs from the "Arts and Trades" series, produced for the 1900 Universal Exhibition of Paris. Also present is the reference to science with the symbol of the hydrogen atom and, in the rear part of the monument, the figure of Ramon Llull, of whom Pujols was considered a disciple and to whom Dalí refers in his pictorial and written work. In 1971, for example, he stated: At the time of the greatest spiritual poverty in which modern art is being annihilated in minimum (or minimalist) art, as its very name indicates, technology, thanks to cybernetics, reaches refinements worthy of the combinatory wheels of the archangel Ramon Llull.

In the adjoining square, on the steps that lead us towards Carrer La Jonquera, there is a second sculpture, *Homage to Newton*, a tribute to this scientist and the power of gravity that he discovered, which appears represented by an apple-ball hanging from a pendulum, a reference to the 1932 Dalí piece *Phosphene of Laporte*, in which Newton appears in the lower part of the oil painting. Dalí also refers to the physicist Giambattista della Porta, author of *Magia Naturalis* (1589), the first systematic treatise on optical lenses and in which he gave an eminently artistic application to camera obscura.

In the same square we see three sculptures repeated in the form an echo. Three acts of homage paid to Jean Louis Ernest Meissonier —the painter that Dalí admired— produced by Antonin Mercié in 1895 and retouched by the painter, who hung tyres around the piece in his anthology at the Georges Pompidou Centre in Paris, held between the 18th of December 1979 and the 14th of April 1980. At the foot of the central sculpture, Dalí inscribed ironically: "Without Gala and Dalí it would not be here yet". On another inscription we read the extract of a questionnaire to Proust, "Which painter do you like most? Ernest Meissonier". The square also features a stone fountain that works as a lamp, the original foun-

Plaça Gala-Salvador Dalí.

tain that Dalí transformed and integrated into his universe and which is crowned again by a reproduction of the hydrogen atom.

In a corner of the square is the sculpture *TheTV-Obelisk* by Wolf Vostell the first European who made an environment and who organised the first happenings in our continent– a monolith with fourteen televisions crowned by a woman's head. In 1978 Dalí and Vostell signed an agreement by which they would exchange works for their respective museums. Dalí authorised Vostell to produce his idea for *The backdrop of Perceval* in the Malpartida Museum in Cáceres.

Dalí complements the square with one of his own works, placed behind a glass display cabinet, containing the cardboard head of a monster, a gift from the painter Rafael Durán, which is supported by a stand made of eggs, with small dolls that make the pupils of the eyes, teeth made with dolls and a television on the forehead. This installation is placed at the entrance to the hall that was once used as the fish market, which connects with what is now called, for this reason, the fishmongers' room of the Theatre-Museum. Worth mentioning are the two medallions, in oil on copper, with the effigies of Dalí and Gala placed over the main balcony of the theatre's side façade.

Around the top of the building is a kind of crown of mannequins that take on different postures. They are art deco figures that Dalí had moulded in synthetic material that was later gilded. The two mannequins at the end of the central façade hold in their arms, raised to the sky, the hydrogen atom, a constant reiteration of his passion for science. On the upper cornice there are the bodies of four white warriors with a loaf of bread on their heads. Once again we come across figures with loaves of bread on their heads, this time on the balustrade of the balcony. They are four women standing that can be differentiated by their attitudes and gestures. They could be the invitation to a ritual dance. All of them are holding the Dalinian crutch, so meaningful in Dalí's imagery. These elements must surely have the meaning here that the painter himself explains in his autobiography, *The Secret life of Salvador Dalí*: "It would take quantities and quantities of crutches to give a semblance of solidity to all that (...) crutches immobilise the ecstasy of certain attitudes of rare elegance, crutches to make architectural and durable the fugitive pose of a choreographic leap". These figures of women also have hollows in the solar plexus, since according to Dalí information is contained in empty spaces. Between them there is a diver in a diving suit, in reference to the talk that Dalí gave in June 1936 for the International Exhibition of Surrealism in London, which almost cost him his life through suffocation. The diver is also an early indication and symbol of the immersion into the depths of the subconscious that awaits the visitor to the Theatre-Museum.

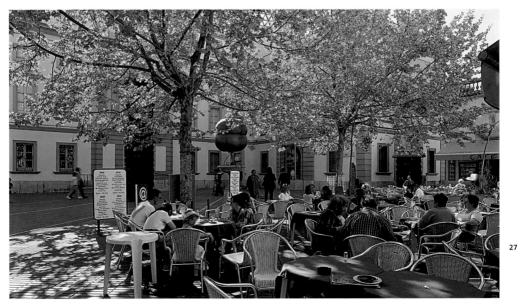

Resting on one of the square's terraces.

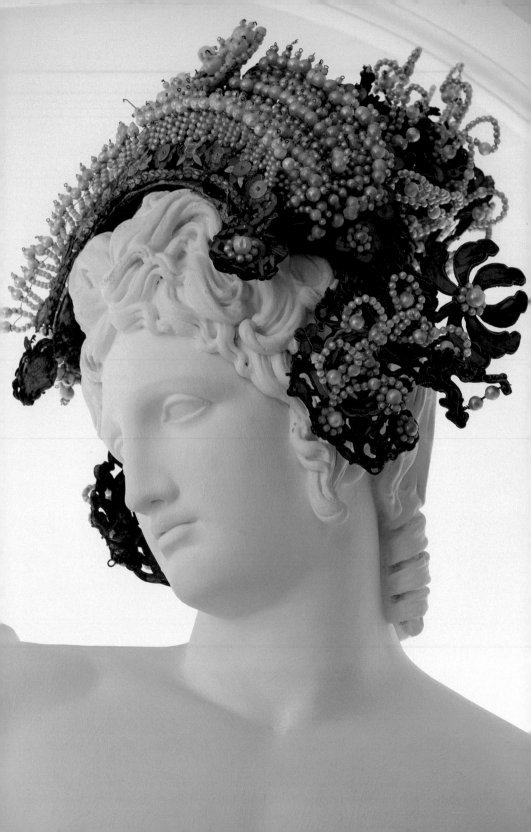

Entry to the vestibule of the Theatre-Museum is made through some glass doors with old iron panels that often appear in surrealist and Dalinian iconography with different connotations, even erotic ones. In this case, Dalí has given them the function of handles. Once inside, we leave behind us the monument dedicated to Francesc Pujols and the church of Sant Pere and, through some large windows, beyond the vestibule, the spectacle of the stage setting of the courtyard-garden appears before us.

This is the space of immersion into Dalinian memory, since just by entering we receive the codes and place the significant artists, people and events of his career and what they have been in order to understand the multiple and complex meanings of his Theatre-Museum.

VESTIBULE

Vestibule of the Theatre-Museum with the classical sculpture of *Ganymedes* "dalinised" with a jewel-gilded cap.

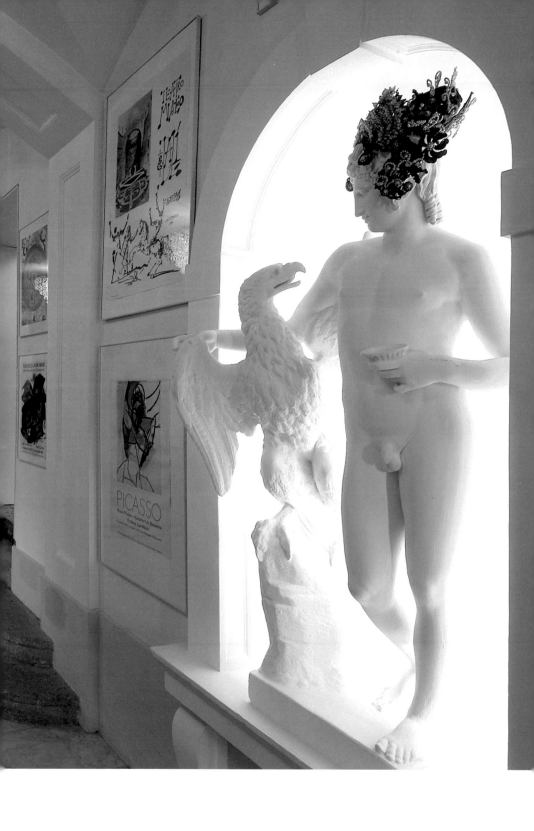

We can see, just on entering, between the ticket office and the door, a photograph of people queuing to see Dalí's first European retrospective, held in the Boijmans Van Beuningen Museum in Rotterdam from the 21st of November 1970 to the 10th of January 1971. The painter loved queues, above all those that formed outside his Theatre-Museum. In the same place there is also a photo on show of Dalí in Portlligat taken by Marc Lacroix in 1974, the year in which the Theatre-Museum opened.

On the right, close to the stairway that will take us up the three floors, we can see a poster advertising the exhibition of work by Antoni Pitxot on the second floor. Next to that is the original poster commemorating the inauguration of the monument dedicated to Francesc Pujols with the calligraphic announcement by Dalí: "Inauguration of: Gala Contemplating the Mediterranean Sea which at 20 meters becomes a Portrait of Abraham Lincoln, the monument dedicated to the philosopher of Catalan thought Francesc Pujols. The sensational Pitxot, Dalí and the Rainy Cadillac, S.D.". This announcement sounds like an invitation to a show and is based on the immortal writing on Trajan's Column —a symbolic reference point for Dalí— and on the advertising poster produced by Dalí himself for the exhibition in the Museum of Modern Art in New York, "Dada, Surrealism and their Heritage", held between the 29th of March and 9th of June 1968. As the press of the time stated: "Dada, Surrealism and their Heritage not only brings together, as the title suggests, three spectacles under the same roof, but also represents a brilliant compilation of the Dada and Surrealist movements, deeply intertwined and which are still the source of a great deal of experimental and avant-garde art", and it is precisely with this in mind that we should begin the visit of this section. We immediately see the original drawing for the "Columbus Day Special Lottery" poster, held in the museum on the 9th of October 1976; a poster for the official opening of the Theatre-Museum in 1974, with a montage of photographs, which shows us an early project for the old stalls —a space that we can make out from here— and a poster referring to the exhibition Picasso held in the Picasso Museum in Barcelona from the 6th of December 1977 to the 10th of January 1978. On the other side there is a lithograph, a project for a ceiling; a poster announcing the opening of the Miró Foundation in Barcelona in 1976; a photo recalling the friendship between Dalí and Josep Tarradellas, the Prime Minister of the Generalitat [Catalan Autonomous Government] after the dictatorship; the comic strip The triumph and verse of Gala and Dalí, written by his friend Carles Fages de Climent and illustrated by the painter, and the original of the Surrealisme poster, which features the

Emblematic posters: Picasso, Miró, surrealism and Dalí.

pairing of "Surrealisme-clasique", complemented with singular examples that were representative for him and for western society. On this poster he associates Comte with Pujols, Moreau with Fortuny and Ledoux with Gaudí. The series is completed with the poster "A 'happening' with Salvador Dalí", held at the Lincoln Center in New York on the 23rd of February 1966; the poster for the Dalí exhibition at the 22nd Salon de Montrouge in 1977; the poster for "Hommage à Meissonier" in Paris in 1967, an exhibition at which Dalí paid homage to and reclaimed the *pompier-style* painters, particularly Meissonier and Detaille; the poster for his "Hommage à Goya" at the French Museum of Castres in 1977 and the poster announcing the publication of 300 copies of *Saliva-Sofa* with photography by Oriol Maspons.

In the niches we can see two identical sculptures, by José Alvárez Cubero (1768-1867), of *Ganymedes*, the Trojan hero chosen by the Gods for his handsomeness as Zeus's cupbearer. Both sculptures refer to the mythological legend that tells how Zeus fell in love with Ganymedes and seduced him by transforming himself into an eagle and carrying him off. On the right, Ganymedes wears a gem-gilded helmet, which came from the Russian Ballets, an ornamentation worn, in this case, by Gala and, on the left, the sculpture appears before a reliquary.

On the left-hand wall, in an exuberant fan-collage made by the model and friend Amanda Lear under Dalí's supervision, there are two photographs of Gala with inscriptions. The most well known is probably the one that has "Tête au chateau" written in the forehead, in reference to the castle of Púbol that the painter gave to Gala. What stands out in both photographs is Gala's gaze, so admired by the poet Paul Éluard, her first husband who, alongside the picture of Amanda Lear herself with vacant eyes and the persistent appearance of the "eye" icon, makes one think that Dalí was making a play on words of the concepts of look and vision. Most of the elements that make up this collage —including the photo of Marilyn Monroe by Philippe Halsman-Magnum, *Mao-ified* by the painter— belong to the special issue produced by Salvador Dalí to commemorate the 50th anniversary of *Vogue* magazine, (1921-1971), in France.

On the other side, beneath the stairs that lead to the other floors in the Museum, an eagle attracts our attention, a donation from *Els Xiquets de Valls*, a Catalan team of *castellers*, the popular human towers, as a homage to the painter of everything that was popular and festive in his country, with the head of a Chinaman in the large central opening of the breast, referring to Dalí's film *Impresiones de la Alta Mongolia*, directed by José Montes Baquer in 1975.

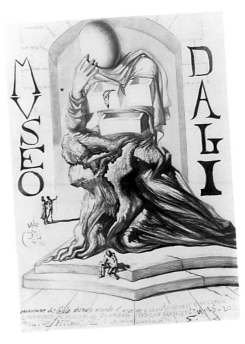

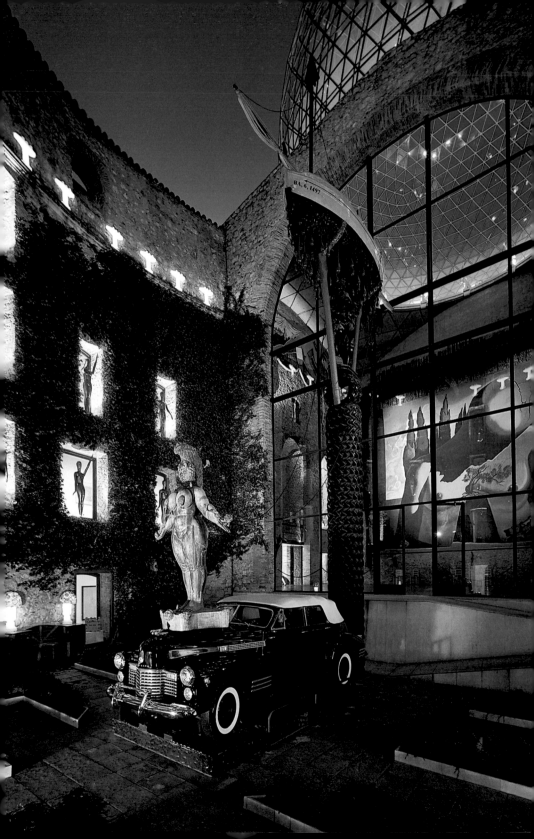

This impressive central courtyard, a garden exposed to the open sky, is the old stalls section of the Municipal Theatre of Figueres. It is dominated by the vertical installation with the imposing Cadillac in the centre of the courtyard; the sculpture of *The Queen Esther* by Ernst Fuchs that pulls, with its chains, the Trajan's Column made of tyres —homage to the Roman emperor born in Hispania who interested Dalí so much—; the marble bust of François Girardon and the Dalí-treated *Slave* by Michelangelo, together with Gala's boat and a black umbrella, elements that comprised, according to Dalí, the biggest surrealist monument in the world.

On the walls of the old theatre, the mannequins welcome us between the remains of the burnt beams, the "grotesque" monsters, the eight bas-reliefs from the "Art and trades" series produced for the 1900 Universal Exhibition in Paris, and the metaphysical washbasins that seem like angels. Also, once again, we have the subtle presence of Salvador Dalí's muse with the four flowerbeds that form the letter G of Gala. Behind the enormous glass-walled door we are given the hint of the stage with the backdrop for the ballet *Labyrinth*, while the music chosen by the maestro enwraps the resonating atmosphere of the entire space.

COURTYARD

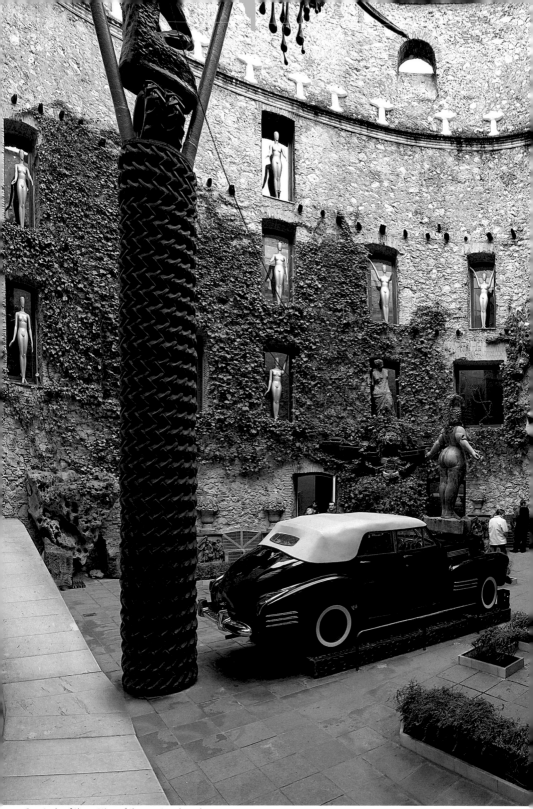

Spectacle of the setting of the courtyard-garden.

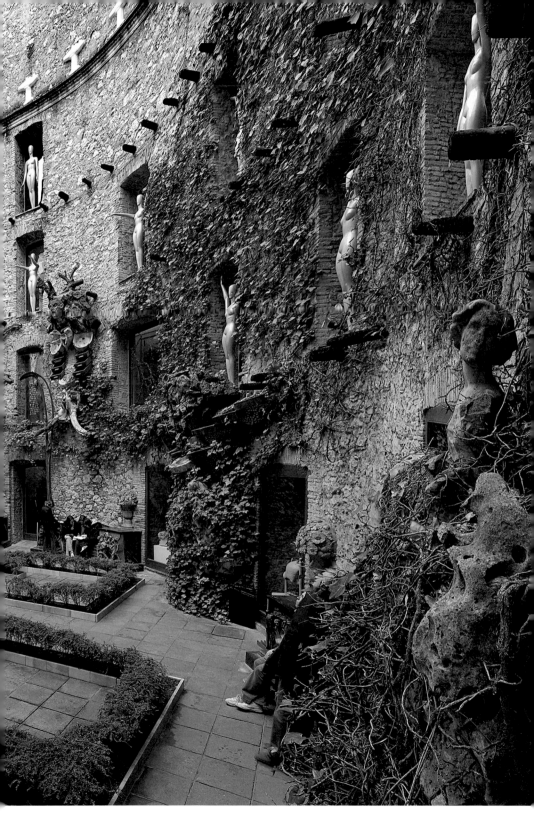

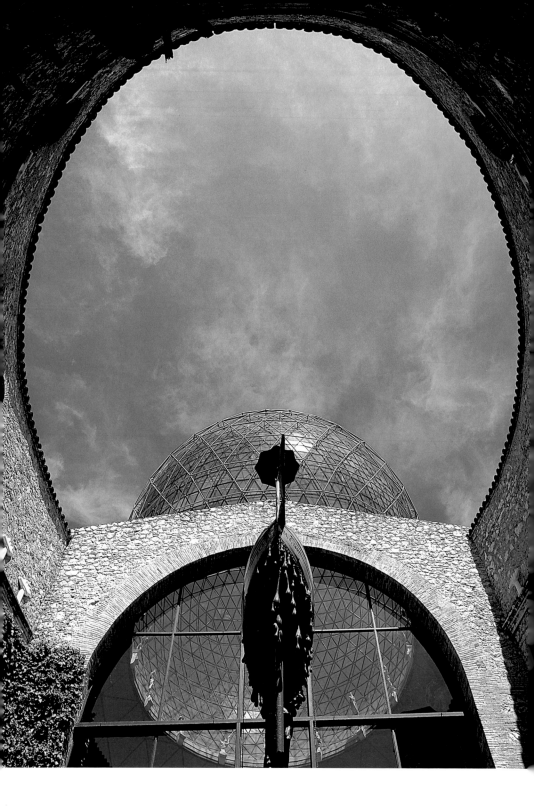

Gala's boat and the black umbrella crown the biggest surrealist monument in the world.

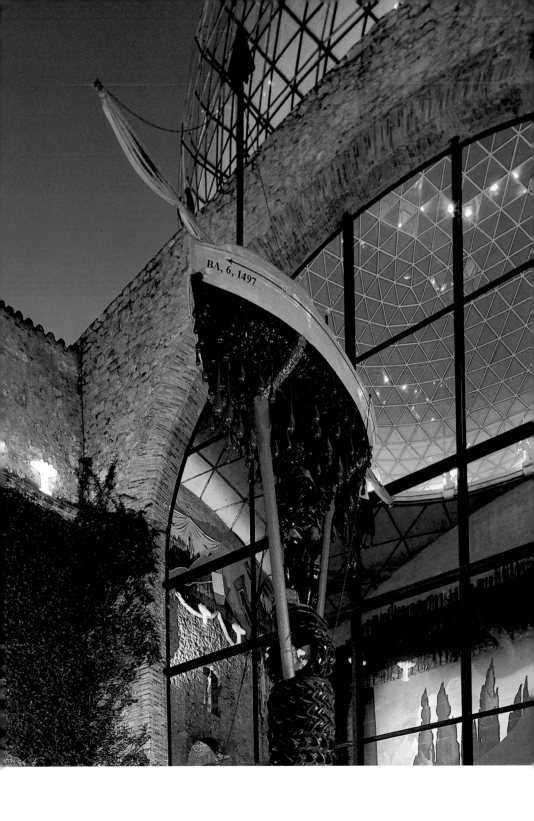

40

Decorative elements that help create the special atmosphere of the central courtyard.

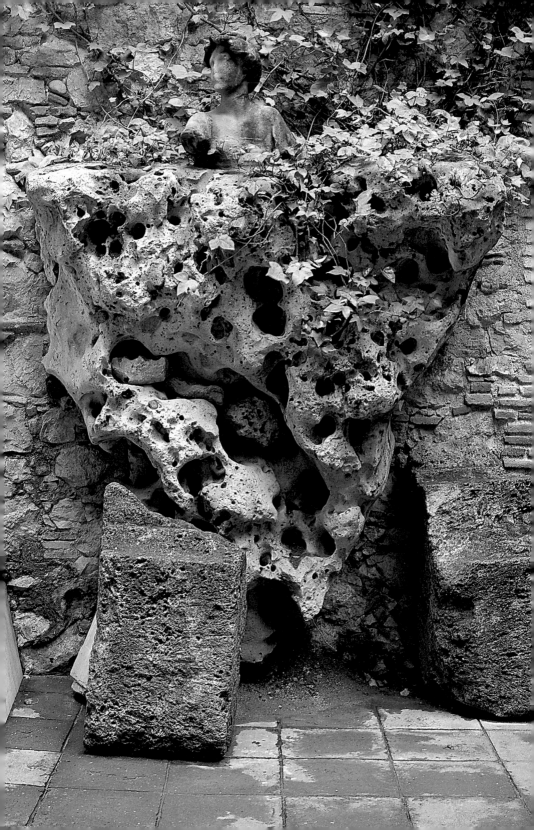

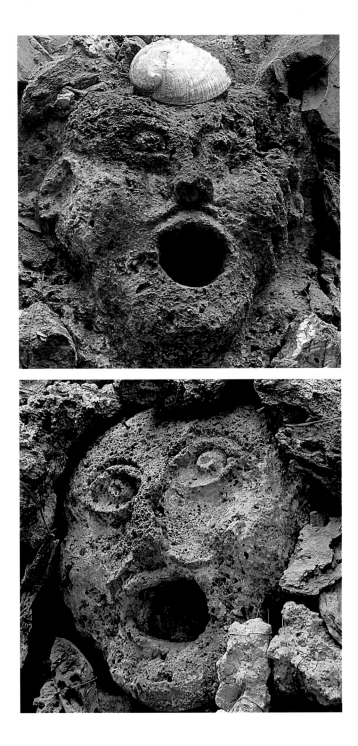

Detail of the "grotesque" monsters' heads that overlook the courtyard.

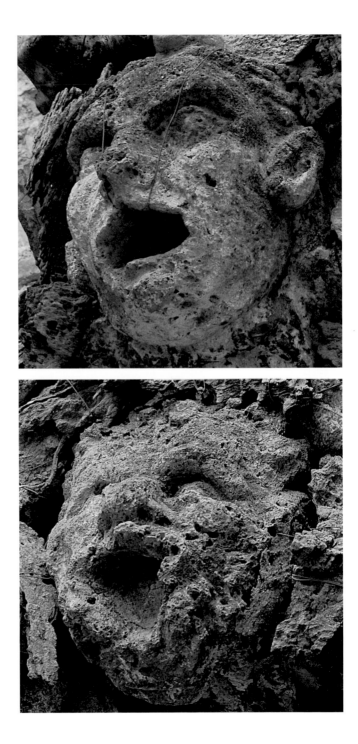

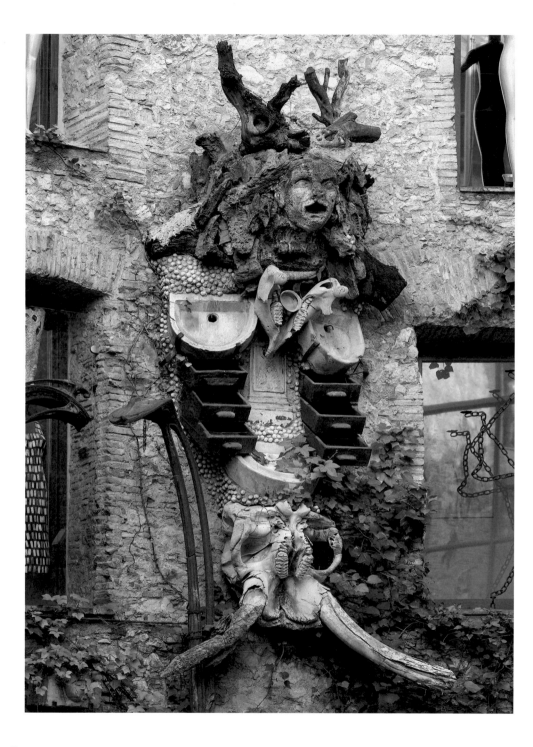

44

The "grotesque" monsters created in 1975 with the collaboration of Antoni Pitxot are situated between the central windows of the courtyard.

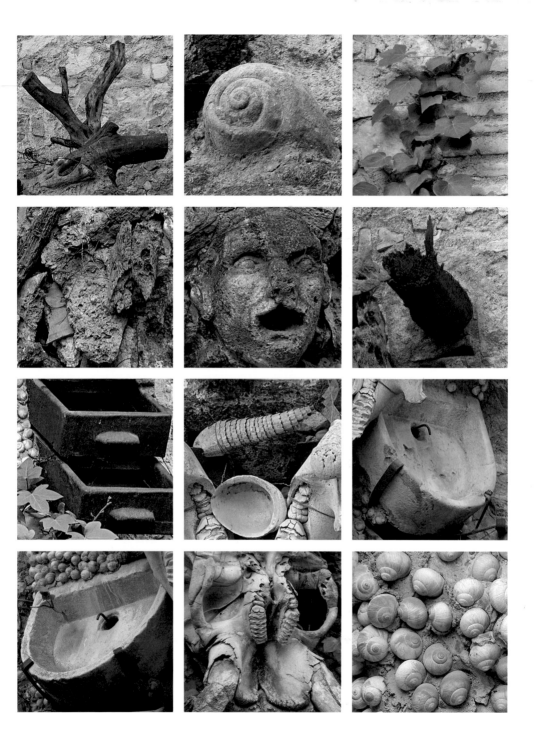

45

These sculptural groups, phantasmagoric beings that emerge from the darkness,
are made up of many elements.

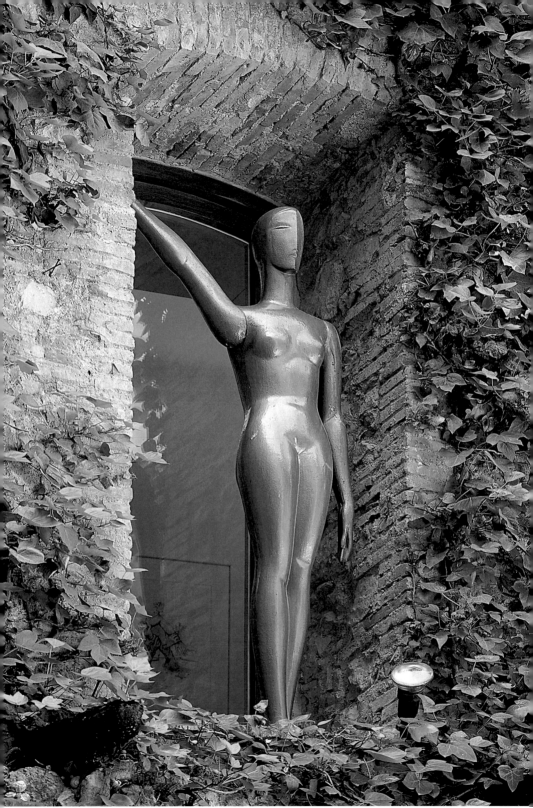

Art deco style gilded mannequin that welcomes us.

Venus velata by Olivier Brice.

This entire setting, which makes up the museum's central courtyard, can be interpreted as a grand installation with a Dionysian sense of ritual, offering, play and festival. On our visit Dalí invites us to take part in a ritual or game and reminds us that our contribution makes us both spectators and creators at the same time.

As visitors-spectators, what surprises us is the sheer size of the installation with the Cadillac called *Rainy Taxi* that was created for the International Exhibition of Surrealism in the Beaux-Arts gallery in Paris in January 1938, organised by André Breton, Paul Éluard, with the cooperation of Marcel Duchamp, as "générateur-arbitre", and Salvador Dalí and Max Ernst as special advisors. The car is a frequent icon in Dalinian creation in which it combines fossil, immemorial matter with that which is most recent in man's history: the machine that provides mobility. This Cadillac, used above all in the United States, was a gift to Gala from Dalí, who confirmed that only six models had been made and, perhaps ironically, awarded one of them to Al Capone, the reason why the model on show in this museum has the windows broken by a supposed act of vandalism. The painter added: "One of them was President Roosevelt, another Clark Gable, etc. This is the fourth reproduction of the famous 'Rainy Taxis' that today have been destroyed. The first one was shown at the surrealist exhibition in Paris and caused a real stir. The second was at the New York World Fair and the third at the surrealist retrospective at the Museum of Modern Art in New York". Here Dalí refers to the hall of the *Dream of Venus*, which he showed at the New York World Fair in 1939 and which could be considered as a rather hesitant early version of the artistic object the Theatre-Museum would become.

Over the bonnet, in the form of a radiator top, the sculpture of *Queen Esther*, 1968-1973, a gift from the Austrian artist Ernst Fuchs, considered by Dalí as a foreshadowing of the *Nanas* by Niki de Saint-Phalle. In the inside of the Cadillac, there is a complex system of piping that sets off an intermittent rain to satisfy the Burgundy snails that accompany the couple of mannequins and their chauffeur.

The boat, which along with the umbrella crown the piece, had belonged to Gala and is supported by crutches, elements with a very high presence in Dalinian imagery. On the column of tyres there is a delicate marble bust of François Girardon, —sculptor and director of sculptural decoration of

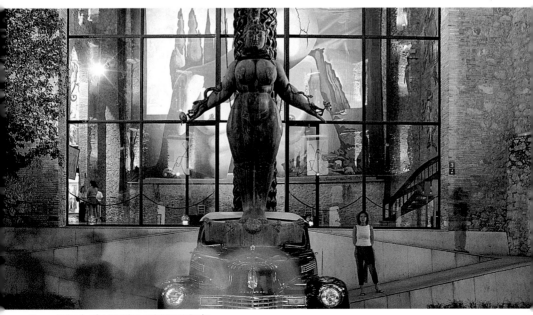

Queen Esther by the Austrian artist Ernst Fuchs.

Versailles after the death of C. Le Brun— over which appears the *Slave* by Michelangelo, painted black and with a tyre crossing over the body (on the third floor, at the entrance to the corridor, Dalí placed *the slave* again, this time with a harness). Worth noting here is the sumptuous series of simulated drops of water that hang from the keel of the boat that the painter designed and painted with such precision, and the already mentioned black umbrella which, with the donation of a coin by the visitor, opens and closes and makes it rain inside the taxi.

On the walls we can see the burnt beams, the result of the fire —purifying according to Dalí—, which, we should not forget, was the origin of the future Theatre-Museum. The artist wanted the stigma of fire to be present. Also of note are the washbasins that form a chorus of angels. Dalí, in a text titled *T*, written in Portlligat in May 1976, wrote: "Long before the Pyramids of Egypt, long before Perpignan station, from the beginnings of *Homo erectus*, the first vision of his soul was a whiter-than-white washbasin of the Roca brand shaped into the categorical figure of a T illuminated by the sun". In the large windows there are twenty-one gilded mannequins in 1920's art deco style, actors of a mnemonic disposition, with different attitudes that contrast with this space due to their cold inexpressive presence.

In the four niches on the first floor, from left to right, is a *veiled Venus* by Olivier Brice; a character constructed with a bronze chain tiled *Homage to Braccelli* —a 17th-century mannerist painter who, along with Luca Cambiaso, interested Dalí for his ability to reinterpret and deform the human figure—; a metallic dress, with the characteristic design of Paco Rabanne, crowned by the gilded skull of a crocodile and complemented in the lower part by a small bronze sculpture, the *Bird-man* (1966), made by Dalí and which gives the installation a certain Egyptian aesthetic; in the fourth niche there is a second version of the *Homage to Braccelli*.

The central entrance door to the courtyard is framed by two original street lamps from the Paris metro by the architect Hector Guimard that rest on a support of fossilised snails from the Pyrenees. Here we should not forget Dalí's constant appreciation of Modernism, above all that of Antoni Gaudí. With this in mind the article that he wrote for the December 1933 issue of *Minotaure*

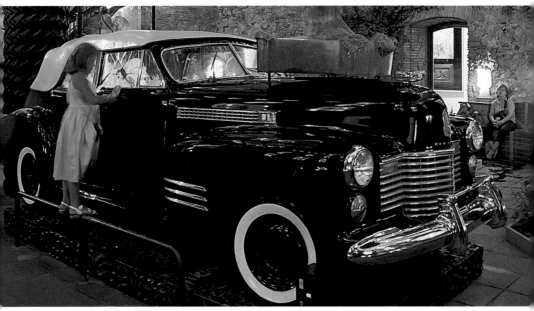

The *Rainy Taxi* overlooks the central courtyard.

magazine is of interest to us: "On the terrifying and edible beauty of Modern Style architecture". Dalí would always defend creative architecture, that provided "machines for dreaming" and which strengthened the "functioning of desires".

The benches, from which we can appreciate this spectacular creation as a whole, are decorated with eight bas-reliefs from the "Arts and Trades" series —produced for the 1900 Universal Exhibition in Paris by the sculptor Guillot and the ceramist Muller— and the alabaster jars, which can be lit up at night and which Dalí had placed in his museum in the period when the Torre Galatea was included (1984-1989). Beside the ramp the climbing plants and the two busts stand out, with a certain shroud of mystery, that had belonged to the Casa Lleó Morera in Barcelona. Also of note are the flowerbeds that form the G of Gala, of which Dalí had commented: "The whole courtyard-garden is sown with murtas in the form of a G. In ancient times it symbolised the bush of love. And they are there in honour of Gala".

Dalí had a theory that one should always proceed by accumulation and never by selection, since time and space would take care of ordering everything else. And he applied this principle to his creative work and to his Theatre-Museum. A good example are the "grotesque" monsters as he liked to call them, created in 1975 with the help of Antoni Pitxot and which we discover between the large central windows of the courtyard. They are phantasmagorical beings that arise from the darkness and contemplate in ecstasy the immense spectacle of the Theatre-Museum from their privileged position in the courtyard. These sculptural groups are made up of many elements: snails; rocks from Cap de Creus; branches from plane trees after a pruning in the Rambla of Figueres that Dalí wanted to make the most of; remains of the gargoyles from the neighbouring church of Sant Pere, also burnt during the Civil War; an old abandoned fountain from the local park or sets of draws from old furniture of the Figueres City Council which, for Dalí, were always containers of information.

The series is made up of four monsters, two of them central, which frame the courtyard entrance. The one on the right, with its structure of fountains, drawers, whale skeleton and stone horn, is

Mannequin and chauffeur that form part of the installation *The Rainy Taxi*.

a male. The one on the left, more ornamented, with shells, snails and tree trunks, has a feminine expression. Both lack arms. The two side monsters, more fragmented, do not have bodies but do have arms that are crossed. The right-hand one is, according to Dalí, slightly aristocratic since on its breast it boasts the coat of arms of an old lineage. All of them appear and seem to be contemplating the spectacle from amidst the vegetation of an abandoned romantic garden, as we have mentioned before. This refers to the park of the monsters in Bomarzo, a spot some 90 kilometres north of Rome and which fascinated Dalí so much that his enthusiasm was contagious and led to the Italians recovering the space. These monsters are also fountains because they have a system that makes water spurt from their mouths. They are turned on at night in August, when night-time visits to the Theatre-Museum are allowed.

The music that accompanies us during the visit was chosen by the artist himself and is the finishing touch to creating the special atmosphere of this space. We can hear *Tristan and Isolde* by Wagner, one of Dalí's favourite composers. Remember that Mad Tristan premiered on the 15th of December in New York, "the first paranoiac ballet based on the eternal myth of love until death". Dalí's argument was based on Wagner's opera *Tristan and Isolde*. Wagner is also present in Dalí's pictorial work. In the corridor of this area, for example, on the inside of a glass cabinet is an oil painting with the same title. Also in the museum we can hear Georges Bizet's opera *The Pearl Fishers* and the sacred lyrical drama *The Elche Mystery*, a performance of which Dalí attended in 1973.

Two white marble ramps, designed from an original sketch produced by the Romanian sculptor Damian, lead us to the glass wall that opens into the stage beneath the cupola. Along with Emilio Pérez Piñero, Dalí had designed a model for a glass door that should have been placed in the centre of the museum as a partition between the stalls courtyard and the old stage area, beneath the cupola. The model, which we can now see in the "Bramante Shrine" room, is made of Methacrylate squares with creations by Dalí of a grand chromatic richness, since the artist wanted the visitor to be impregnated with images and receive a really strong visual impact.

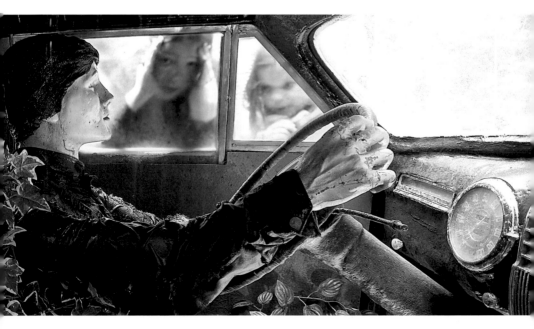

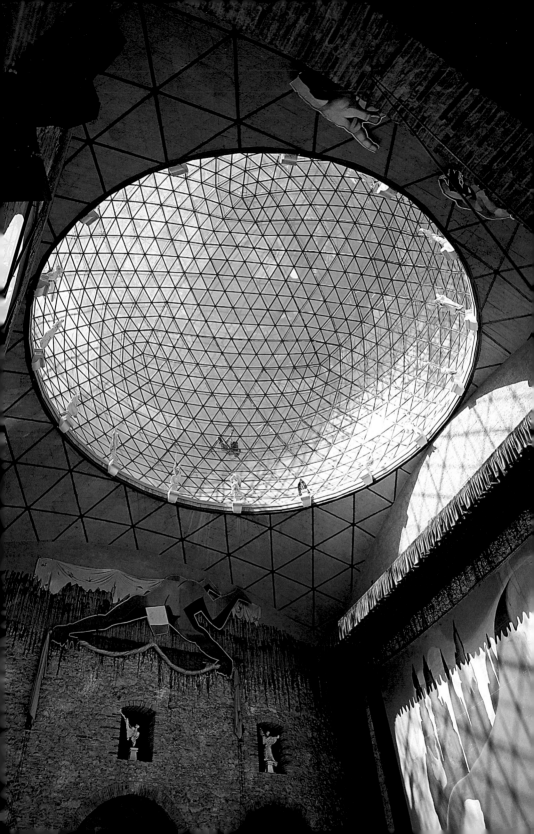

From the courtyard, going up the ramps, we reach a truly impressive space: it is the stage of the old Municipal Theatre, crowned by a stunning geodesic cupola that has become the symbol of the Theatre-Museum and, by extension, of Figueres. At night the cupola is reflected on the large glass wall that separates the courtyard-garden from the stage and creates a vision of seeing the courtyard covered by a second cupola. An effect of mirror images and multiple images is created.

Dalí wanted one of the cupolas to be transparent and reticular, a structure that was a speciality of the North American architect Richard Buckminster Fuller, although in the end the person who under-took the project, almost certainly recommended by Fuller himself, was the architect Emilio Pérez Piñero. In the July-August 1972 edition of *Arquitectura* magazine, in reference to the architect's death, Dalí made the following statement in relation to the cupola: "...and nothing more glittering and purposeful than this roof by Piñero, on which seeing it from all its sides it seems that there are other structures and all these structures end up being synthesised into a glorious everlasting light. In other words, in the most modern of all Spanish architects, you find not only the great designs of the Italian Renaissance by Palladio, but also the categorical affirmation of faith of our great architect Herrera, the constructor of El Escorial". He also mentioned on many occasions that for him the cupola was a symbol of unity and monarchy.

THE CUPOLA

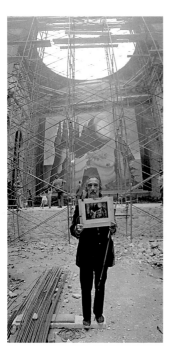

"Start the house with the roof, just as the great architects of the Renaissance did, who imagined what the cupola would be like before all else."

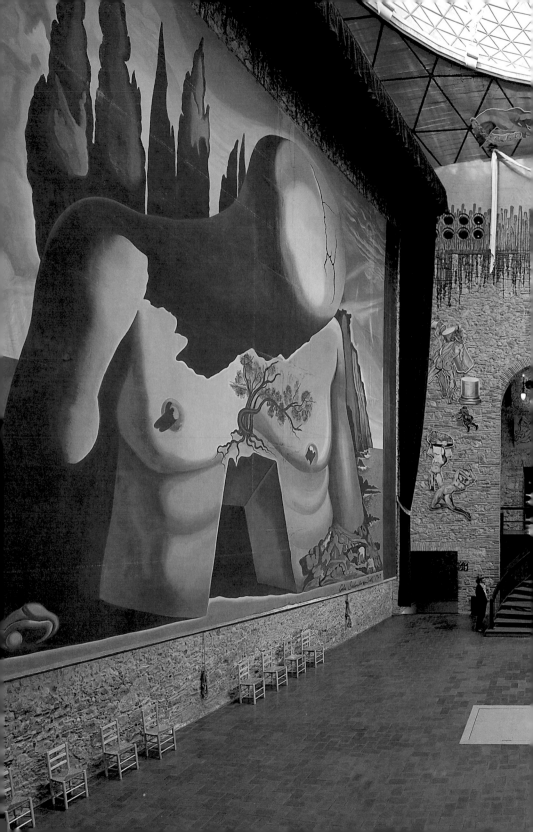

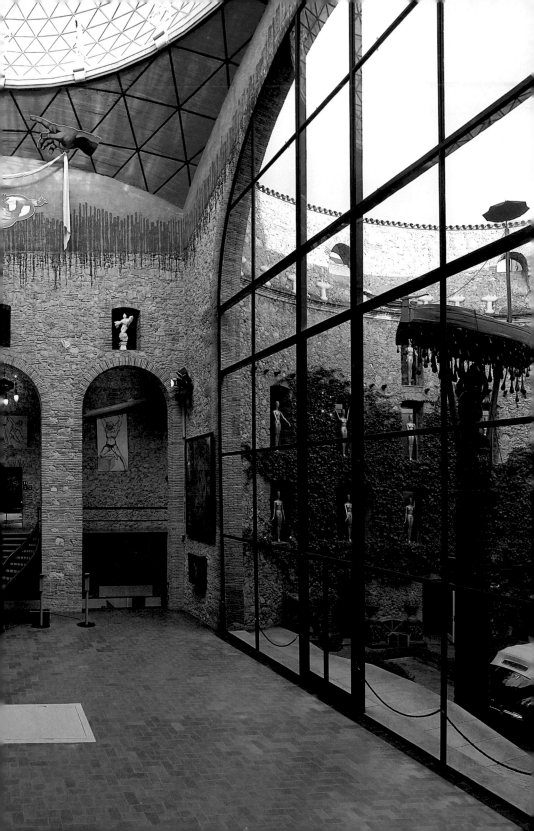

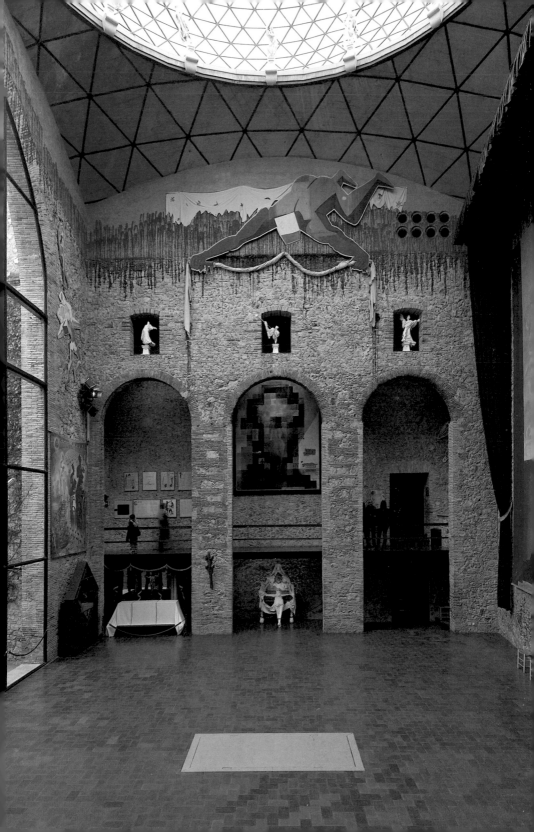

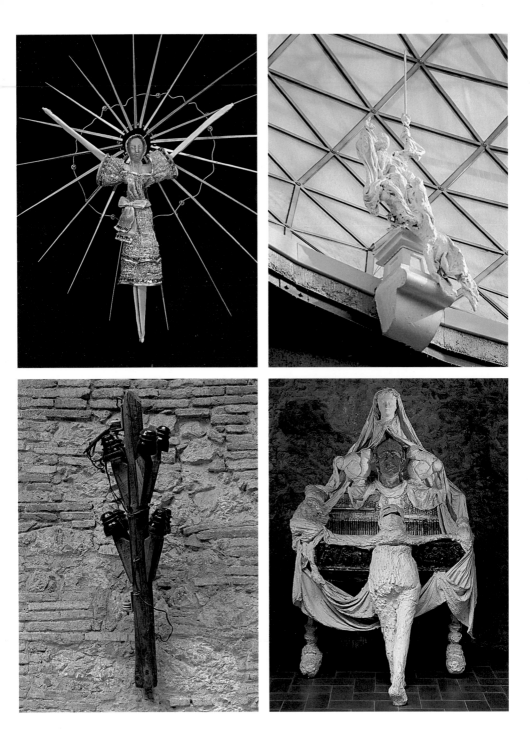

Dalinian installations beneath the geodesic dome.
← Stage of the Municipal Theatre, an impressive space.

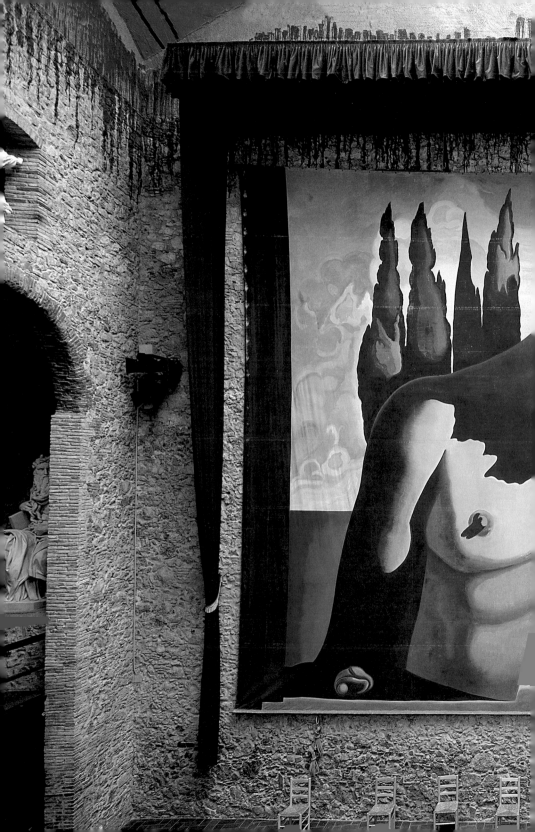

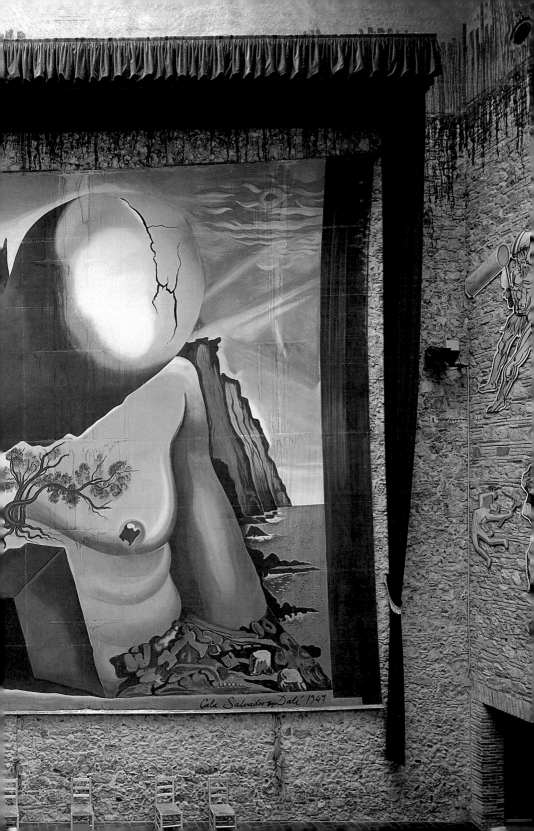

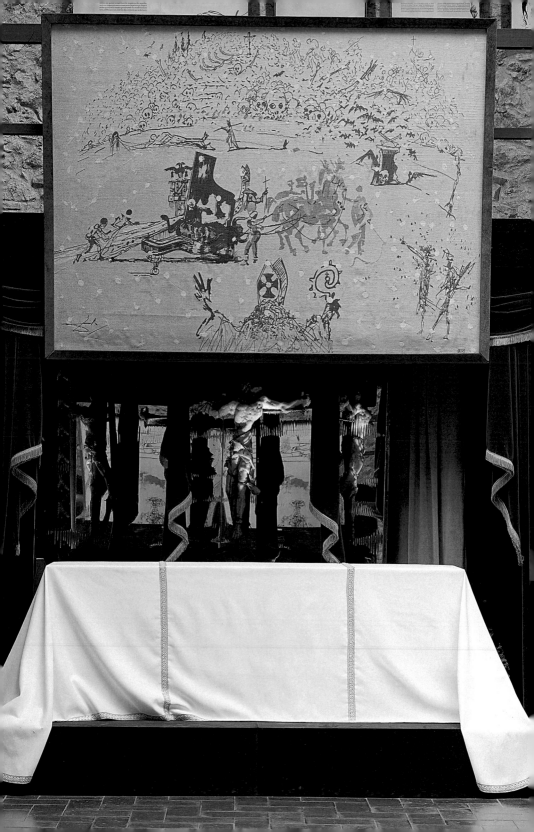

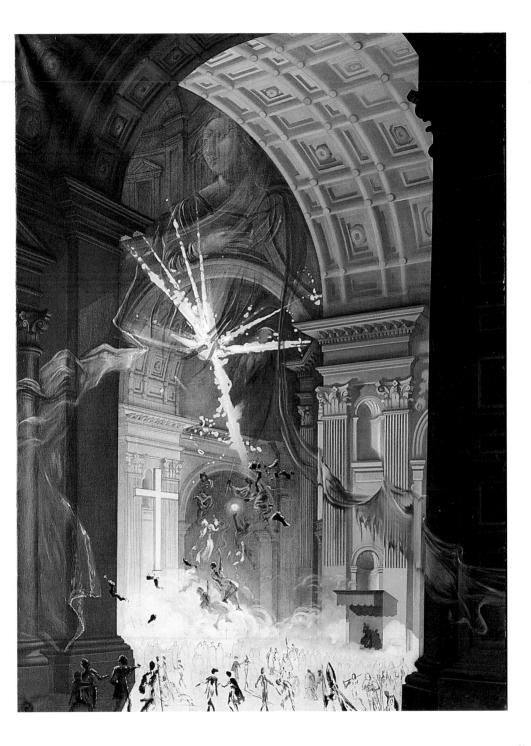

61

Explosion of Mystical Faith in the Centre of a Cathedral, oil on canvas, 1974.

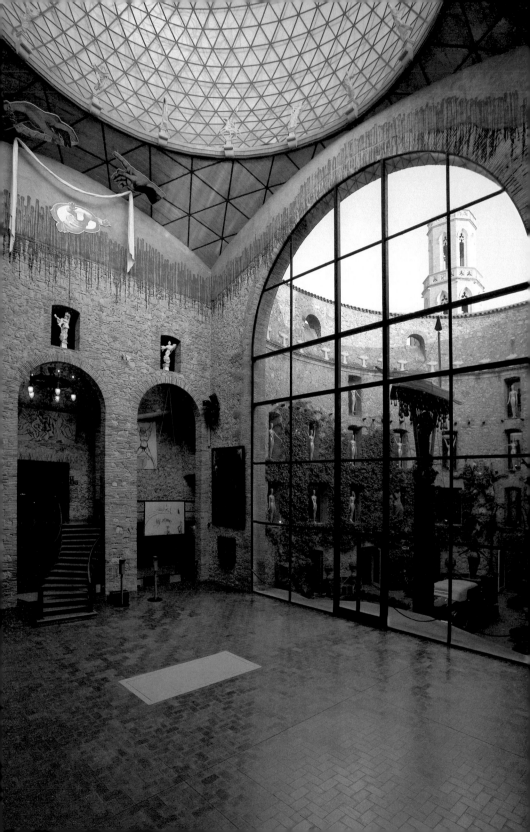

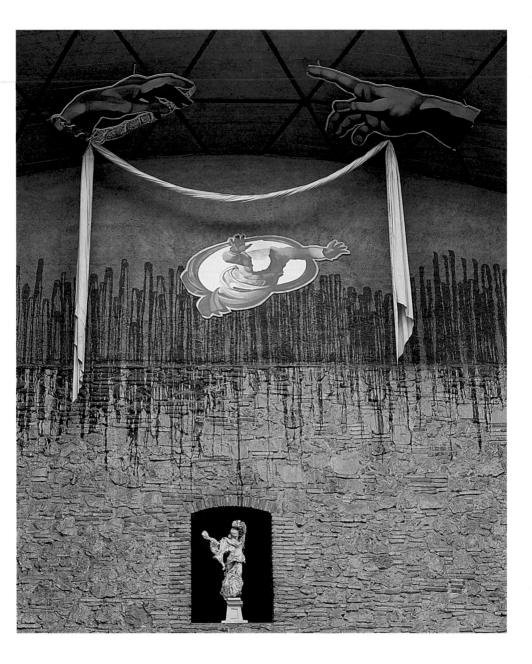

Part of the set in homage to Michelangelo's Sistine chapel.

← View of the central courtyard and the bell tower through the large glass window.

Once the cupola had been installed, Dalí wanted to improve the aesthetics of the vaulted area: he painted a false reticular structure red and all the background of the supporting vaulting blue, completing this setting with sixteen plaster sculptures he had made in Portlligat. They are protective characters of the Museum, with gesticulating or heroic attitudes, bearing trumpets, staffs or period clothing, except one, naked and with a cape over its shoulders symbolising permanent surveillance and, for this reason, is always illuminated. They are plaster casts with an expression of movement that is best expressed in the shaping of the drapery, due to the fact that he made them outdoors on days when the Tramontana wind blew.

Dalí's intervention in the museum is present down to the smallest details. For example, on the right-hand wall we can see a giant with a cubic head that is wringing out a blue sheet, started by the suggestion on the wall of some marks of the same colour that Dalí converted into dripping washing. The meaning behind this character is that of rainmaker. On the left, two enormous hands hold a sheet, in this case, a white one. We can see other gigantesque figures on the walls. They are photographic reproductions of the originals because the conditions beneath the cupola do not allow such delicate works to be exhibited. Many of the originals can be seen in the "Bramante Shrine" room. The setting as a whole clearly refers to Michelangelo's Sistine chapel, although ironically Dalí stated that his characters enjoyed the privilege of being able to change place.

Hanging from the sides of the arches, at the height of the first floor gallery handrail, we are attracted by some tapestries that come from a series of seven engravings called *Surrealist Bullfighting* (1966-67), based on the *Bullfighting* by Pablo Picasso in 1957, even though Dalí's interpretation of bullfighting is much more critical than that of the Malaga painter.

Overlooking the stage, the massive backdrop produced in oil that Dalí designed for the ballet *Labyrinth*, based on the myth of Theseus and Ariadne, which premiered in the Metropolitan Opera House in New York on the 8th of October 1941, with choreography by Léonide Massine, music by Schubert and libretto, decoration and costumes by Dalí. This space reveals the most scenographic aspect of Dalí: with the enormous composition, where a bust appears with an opening in the breast,

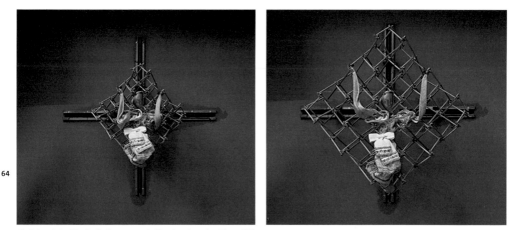

Christ painted by Dalí above a metallic structure by Pérez Piñero.

from behind which emerges a phantasmagoric landscape with Böcklinian cypress trees from *The Isle of the Dead*. The rocks, sinking into the sea, are a reference to the scenery of Cap de Creus, which the artist repeatedly turned to in his work. In front, on the stage itself, is an extremely discretely placed tombstone, reminding us that this is where the artist is buried, in the radial centre of his own Theatre-Museum.

On the right is the huge, stunning photographic oil painting *Gala Nude Looking at the Sea, which, at 18 Metres appears as President Lincoln* (1975) **[C47]** Homage to Rothko , another anticipative demonstration by Dalí that in this case represents the first example of the use of the digitalised image in painting. The artist stressed that this was paying homage to the North American painter Mark Rothko. There is another slightly different version. On either side of the old stage entrance, closed off by a large transparent glass casing are two large-format works on show. On the right, we can see the reproduction on canvas of the *Hallucinogenic Toreador* (c. 1968-70), which is held in the Dalí Museum in Saint Petersburg, Florida, in which Dalí pays homage to the bullfighter Manolete and where once again he develops the concept of the double image. In 1968 Dalí began producing this immense work after seeing, on a pencil box manufactured by Venus Esterbrook, the nose, cheek and mouth of a bullfighter in the illustration of the *Venus de Milo*. We will recall that Venus is a recurring theme in Dalí's creative work. As is the double image, which in this case we can see the face of the bullfighter Manolete repeated on the red cape. Dalí wanted it to be an oil painting, like his canvas *Apotheosis of the Dollar* (1965) **[C40]**, that combined all the imagery that he had used until that time: the *Venus de Milo*, Gala, the bust of Voltaire, the flies, the self-portrait —a child Dalí dressed as a sailor—. The most powerful hallucination is the apparition of Gala's face on the terracing of the bullring with a luminous halo in line with apparitions. On the other side is another large oil painting, *Roger Freeing Angelica*, also known as *Saint George and the Maiden*, a replica, according to the painter, of the *Angelica* by Max Ernst and of which he explained: "We just need to study the complexity of the curves, first the arms, then, where they are interrupted, another absolutely divine curve, a categorical straight line, worthy of Juan de Herrera, the architect of El Escorial, and, suddenly,

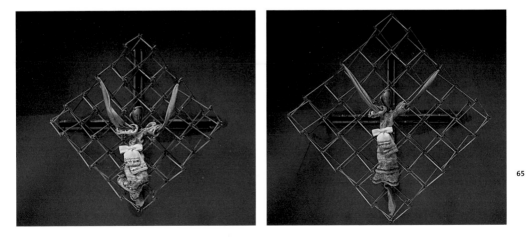

the hip, which is the maximum point, a line worthy of the immortal Greeks". We have the evidence, even photographic, of the person who served as the model, Amanda Lear, who for a long time formed part of the entourage of Dalí's friends and collaborators.

Below each of the works mentioned, on the inside of a glass cabinet, is a Christ painted by Dalí on parchment, installed on a metallic folding structure designed by Emilio Pérez Piñero. It is the figure of Christ that, by inserting a coin, unfolds with open arms. Only the Christ that is permanently unfolded, however, situated over the work *Roger Freeing Angelica*, is original. The other is a modern version that enables us to see how it works without spoiling the work of art.

On the right, towards the Treasure Room, we come across a new installation by Dalí with an altar overlooked by a wax sculpture titled *Christ Twisted* (1976). Soft and curving forms, this Christ, according to Dalí, suffers so much physically that even his own cross twists up. With this work, Dalí paid homage to Gaudí the sculptor of the Sagrada Familia, who used mirrors in the same arrangement to give a simultaneous vision of his creations. Moreover, we can discover in a reverse mirror, the reflected image of the oil painting *Explosion of Mystical Faith in a Cathedral's Centre* (1974) to create the sensation of distance and more depth for the spectator.

Then Dalí had a streetlight installed with glass and porcelain insulators, an object found by the painter who, on recovering it and installing it in such a visible spot, wanted to give it importance.

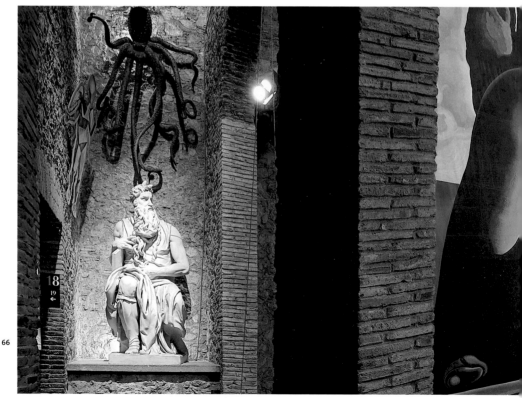

From *Moses and Monotheism* to the oil painting *Michelangelo's Head*.

According to Dalí, this object would be of most interest to archaeologists in the distant future when they looked into the origins of the Dalí Museum and his civilisation.

Continuing our tour, we can see an ink drawing and collage with flies on cardboard, *Saint Narcissus with Flies* (1973), referring to the fact that the French army was defeated by a plague of flies while laying siege to the city of Girona. According to the legend, told by Vicenç Domènech in the book *Flos Sactorim*: "After entering the city the French did such bad things the people could not bear it... they even desecrated the churches (...) and after looting them, robbing the chalices and liturgical vessels, broke the arm off the body of Saint Narcissus... God punished this insolence by making great swarms of half green, half blue flies with red stripes come out from the martyr's sepulchre, which entered the noses of the horses and men and did not come out until they fell to the floor dead". Dalí thought that the fly was the critical-paranoiac insect par excellence. We then come across a sculpture, in honour of *El Poll i La Puça* [the Louse and the Flea], Amadeu Torres and Teresa Marquès, two legendary characters from his childhood memories, two popular characters from Figueres at the beginning of the century, who played the barrel organ in the streets for a few coppers. Before entering the Treasure Room, to the right of the door is an ink drawing that Dalí created retouching the footprint left by a model on a background of canvas or paper, imitating the anthropometries of the French artist Yves Klein.

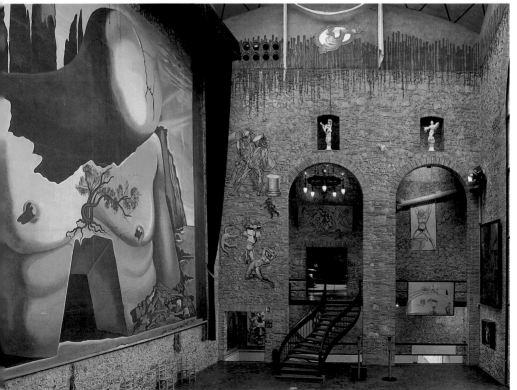

Given this name by Salvador Dalí himself, it is a room upholstered in red velvet, deliberately secluded, conceived like a casket for keeping jewels. It contains some of the most important works in the Dalí Theatre-Museum and, at the same time, the most charismatic for the artist. Once again, his creative work is presented voluntarily without any chronological order and suggests an interesting play of analogies and contrasts to the visitor, aesthetic and intellectual references that takes us to the history of art, the Renaissance and, in particular, to Raphael, to the historical avant-gardes, to science, to Gala, and to himself in the form of a self-portrait, to his omnipresent landscape or to the painter Marià Fortuny. We therefore find in this room many of Salvador Dalí's obsessions and preferences.

TREASURE ROOM

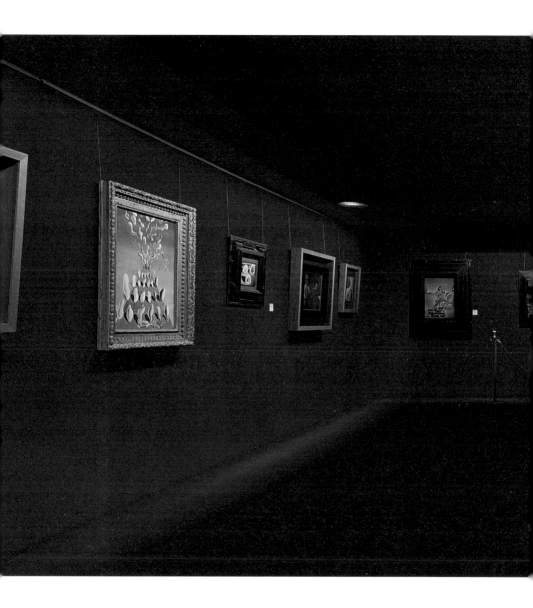

The room-cum-treasure chest, upholstered in red velvet.

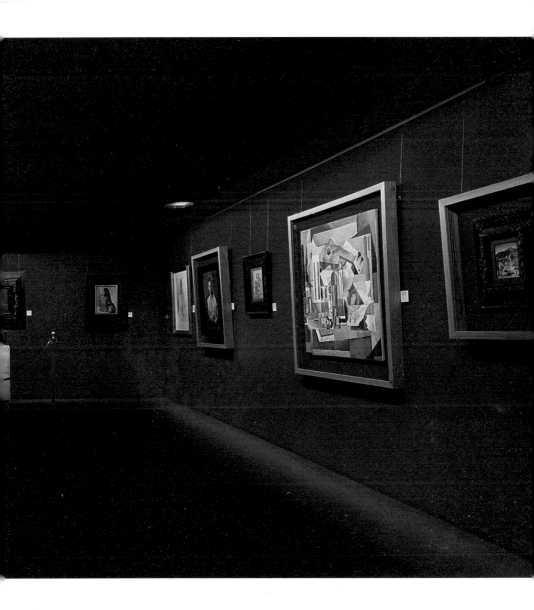

On entering this room, we are faced with *The Basket of Bread* (1945) **[C31]**, an emblematic oil painting that he always travelled with and which was the best gift he had ever given to Gala: a work full of mystery, the total enigma. Chosen as representation of the Marshall Plan of economic aid for postwar Europe, it has been the object of many studies and many declarations by Salvador Dalí. Below we highlight a very significant one and which provides us with the guideline for analysing this oil painting: "For six months, my aim has been to recover the lost technique of the classics, reaching an immobility of the pre-explosive object. It is the most rigorous painting from the point of view of geometric preparation. The structural tensions reach their utmost limits. After this bread there will be a corpuscular explosion. Twenty years later the basket has become a crown and the bread achieves the unity of the elbow and the horn of a rhinoceros".

This work is accompanied by the presence of Gala, his wife and inspirer. On the right, *Gala from Behind Looking in an Invisible Mirror* (1960) **[C39]** and, on the left, *Leda Atomica* (1949) **[C34]**, a work in which the artist's interest in science can be clearly seen. Regarding this oil painting, Dalí stated: "I cannot ensure that my *Leda* —in which all gravity is in space— is a masterpiece. In the period of terrifying mechanical progress and of spiritual decline in which we live it seems impossible to me. I can, however, guarantee that this work will be a masterpiece in Dalí's production. I can also guarantee that it is of more merit to create beauty in 1947 than under the paternal protection of a Perugino. I still need four months to finish *Leda*. When I have finished it, I will show it again in New York and the next day go to Europe —taking in extremely light but skilfully built boxes— *Leda* in my right hand, *The Basket of Bread* in my left hand and a wheatear in my other right hand, that is Gala's hand". Two more oil paintings, *Galarina* (1945) **[C32]** and the one called *Gala contemplating the Corpus Hypercubicus* (1954), a study of the definitive *Corpus Hypercubicus* painting, which is exhibited in the Metropolitan Museum in New York, and the drawings *Study for "My Wife, Nude, Contemplating her Own Flesh Becoming Stairs, Three Vertebrae of a Column, Sky and Architecture"* (1945) —acquired by auction

The oil painting *Galarina*, 1945. A play on glances.

by the Fundació Gala-Salvador Dalí and exhibited, because of its subject matter and relationship, beside the already mentioned *Gala Nude from Behind Looking in an Invisible Mirror* **[C39]**— and *Portrait of Gala Laughing* (1969) place even more emphasis on the powerful presence of Gala in the Theatre-Museum and in this room in particular.

We must also make mention of the marvellous oil painting, small in size, *The Spectre of Sex-Appeal*, from 1934, **[C19]** ina which he himself appears as a child dressed as a sailor contemplating the monster of sexuality; the *Self-portrait being Duplicated into Three* (1926-27), of a markedly futurist inspiration, with the triple silhouette characteristic of the artist in this period; *Siphon and Small Bottle of Rum (Cubist painting)*, from 1924, **[C8]** a sketchy work that is full of symbolism, in which the Italian influence —Giorgio de Chirico and the metaphysicists— is clearly present; *Port Alguer* (c. 1923) **[C5]**, a view of Cadaqués painted in the open air; the clear reference to Marià Fortuny in *Study for The Battle of Tetuan* (1962), with this meaningful dedication written in French: "For Gala, east wind of my life, Dalí 1962", and in which we can notice the lack of faces in the warriors and the precision of the representation of the horses; and the unfinished *Portrait of Ramoneta Montsalvatge* (1925), a character from Figueres with a certain air of mystery. As regards the *Portrait of Gala Laughing*, also titled by the artist *Portrait of Gala taking advantage of paper marks*, and the cover illustration of the catalogue *Dalí: Paintings and Drawing*, 1965-70, of the M. Knoedler Gallery in New York, Dalí expressed his desire to be welcomed by Gala's smile every time the room is visited and for this reason this drawing has always been exhibited here, in the place indicated by the artist.

According to exhibition requirements for replacing any of the abovementioned works, this room can show other oil paintings: *Cubist Composition. Portrait cubist of Federico García Lorca* (c. 1923), *The Girl of Figueres* (1926) **[C11]**, *Portrait of Emilio Terry* (1934), *Man with His Head Full of Clouds* (1936), *The Image Disappears* (1938)**[C23]**, *Group of Women Imitating the Gestures of a Schooner* (1940), *Triple Apparition of Gala's Face* (1945), or *Dematerialisation Near the Nose of Nero* (1947).

Dalí is often featured on the cover of books, magazines and catalogues.

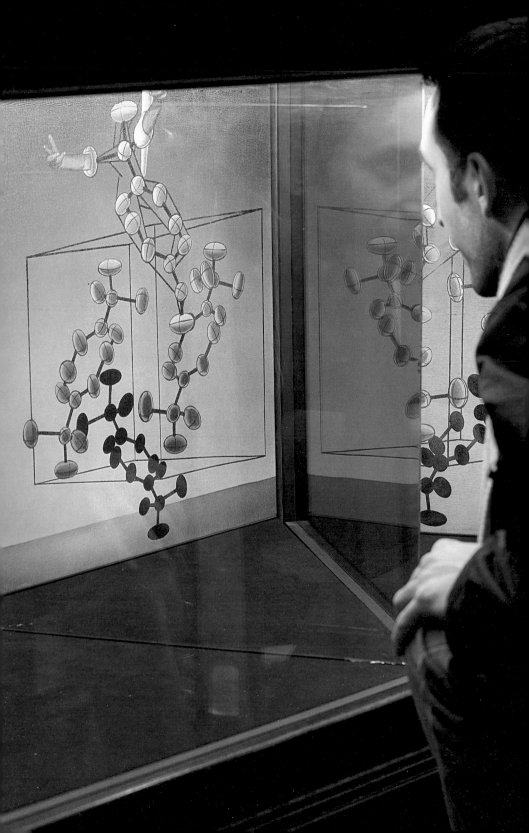

Once again in the space beneath the cupola, just on the other side of the stage, we go down a few steps that lead us to the Fishmongers' Room and first see an ink wash and feather collage on paper, *Head of Beethoven* (1973), a large work that Dalí produced throwing live octopuses over the paper on the floor, taking advantage of the graphic art forms of the ink. One can also see the footprints of some espadrilles that the painter usually wore, which provided evidence for him to state that he had produced this work with his feet.

Continuing, after the oil painting *Surrealist Angel* (c. 1977), at the end of the stairway on the left, there is a large room that Dalí called the Fishmongers' Room because for a time during which the Municipal Theatre has been in ruins, a large space, that included this room, was used as the Figueres fish market.

Facing us we come across another three rooms. In the first one, exhibited alternatively are works from the *Christmas cards* series that he produced for the Hoechst company between 1958 and 1976, and drawings and watercolours that he created to illustrate three grand works of universal literature: the *Autobiography of Benvenuto Cellini* (1945), *Quixote* by Miguel de Cervantes (1945) and the *Essays* by Montaigne (1947). In the next Room the "Dalí d'or" [Golden Dalí] room, are exhibited the series of jewellery that he designed; and finally, we come to the crypt, an austere space, where the tombstone is located. From here we can go along the corridor where, since 1978, the works of the painter and friend Evarist Vallès have been on show.

FISHMONGERS' CRYPT

The Fishmongers' Room with the hydrogen atom lamp.

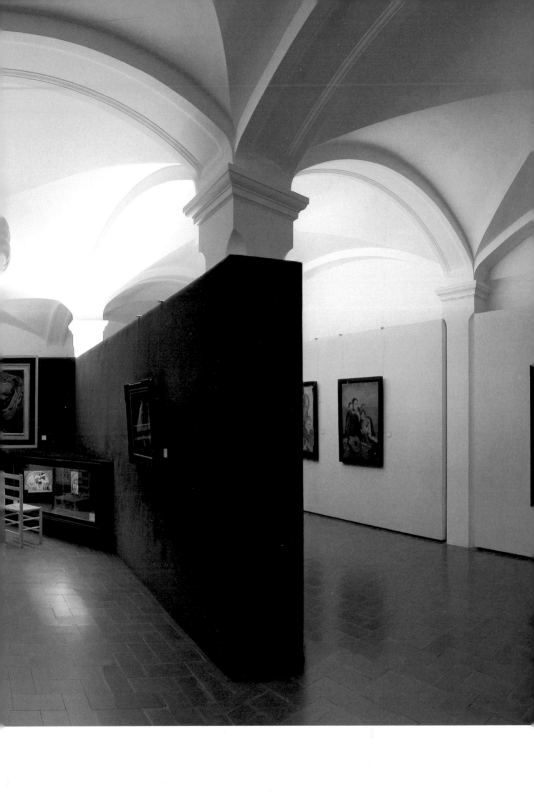

"Dalí d'or" Room. Numbered medals and mounted in items of silversmith work with the double effigy of Dalí and Gala.

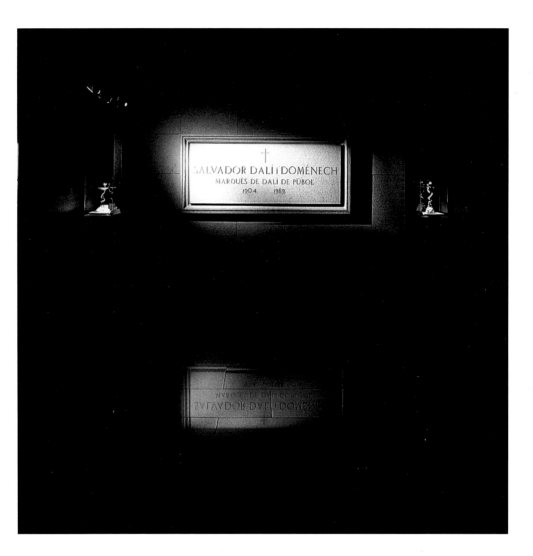

The crypt is overlooked by Salvador Dalí's tombstone accompanied by six caduceuses from the series "Dalí d'or".

The Fishmongers' Room has a series of works covering different periods of Salvador Dalí, though work from the early and late periods dominate. Entering on the right, we can see the oil on cardboard painting *Satirical Composition* ("The Dance" by Matisse) (1923) **[C7]**, clearly inspired by Matisse, followed by the oil paintings *Domestic Scene* (1923), *Self-portrait with L'Humanité* (1923) **[C6]**, *Untitled*. *Two Girls* (c. 1922), *Female Nude in a Blue Background* (1923), and, on the facing wall, two disturbing works incorporating collage with natural substances: *Moonlight* (c. 1928) and *Symbiotic Woman-Animal* (1928), another clear example of Dalí's anticipation of the century's aesthetic trends. There are then two compositions on show —Surrealist Composition: *Arm* and Surrealist Composition: *Torso* (c. 1928)—, foreshadowing the surrealist period, and four oil paintings from the late period: *Geological Echo. La Pietà* (1982) **[C52]**, *Othello Dreaming Venice* (1982) **[C53]**, *The Path of Enigmas* (1981) **[C51]** and *The Cheerful Horse* (1980). Dalí did not want his work in the Museum to be subjected to any form of chronological classification or standardising. Immediately after, in a glass cabinet, is the installation-sculpture *Lilith-Homage to Raymond Roussel* (1966), made up of two works in bronze by Meissonier and a double *Victory of Samothrace* we should recall the influence that the French writer Raymond Roussel had on the surrealists, above all his work *Impressions d'Afrique*, the same title as an oil painting that Dalí produced in 1938, and the source of inspiration for his previously mentioned film *Impresiones de la Alta Mongolia* (1975). Opposite the cabinet we can see the oil paintings *Putrefied Bird* (1928) **[C15]** and *Moon and Sea snail on a Rock* (c. 1928), and, in the central rectangle, once again velvet covered in red, is exhibited the S*oft Self-portrait with Grilled Bacon* (1941) **[C26]** and, in front of it, significantly, the *Portrait of Pablo Picasso in the XXI century (one of a series of portraits of geniuses: Homer, Dalí, Freud, Christopher Columbus, William Tell, etc.)*, from 1947 **[C33]**, an allegoric homage to the painter from Malaga. *Rhinocerontic Figure of "Illisus" of Phidias*(1954) **[C37]** closes the circle, in which Dalí combines the Hellenic torso and the rhino horn with the mineral landscape of Cadaqués. In the two lower cabinets, two examples of stereoscopy, and totally mechanical processes in the optics of perception of the third dimension —we could see more examples on the first floor, in the Stereoscopy Room—. The first, with the double oil painting *DNA Structure* (c. 1975-76), where Dalí represents the characteristic double helix around a central axis and the second, made up of two oil paintings from 1979-80 titled *Athens is Burning!* The right-hand part of the stereoscopic work is based on *The Fire in the Borgo* and the left-hand side on *The School of Athens*, both fresco paintings by Raphael that are kept in the Pontifical Palaces of the Vatican. Dalí wanted to link the stereoscopic vision with two masterpieces by Raphael and thus create a combinatory visual effect in the spectator. On the ceiling, what attracts our attention is the spectacular golden form of the symbol of the hydrogen atom.

The oil painting *Portrait of Pablo Picasso in the 21st century* from 1947.

Leaving the room, facing us, we can visit an area made up of three rooms and which form an early extension of the Museum. The first room shows drawings and watercolours that the painter produced to illustrate *Don Quixote* by Cervantes, the *Autobiography* of Cellini and the *Essays* by Montaigne, and where Dalí clearly shows his deep knowledge of the works of the masters of the Renaissance. This room sometimes exhibits the collection of *Christmas cards* that he designed for the Hoechst Ibérica company between 1958 and 1976. In them Dalí brings together both art and science, his two main interests, in such a way as each year the card refers to the events and scientific advances being made at the time: man reaching the moon, optical illusions, the micro-cosmos, printed circuits... Next comes the "Dalí d'or" Room, where there is a series of medals on show, numbered and mounted in pieces of goldsmith work, dated between 1966 and 1975, issued by Jean-Paul Schneider, and which show the double effigy of the painter and his wife, Gala.

Finally, we reach the crypt, dominated by the tombstone made from Figueres stone, bearing the inscription "Salvador Dalí y Domènech. Marquis of Dalí of Púbol. 1904-1989" accompanied by six caduceuses from the same "Dalí d'or" series. From here we go to the space overlooked by Dalí's dedication: "Vallès is the only painter that has stuck drawing pins into the sky of Empordà", with oil paintings and sculptures produced between 1971 and 1988 by Evarist Vallès, a painter of metaphysical spaces, who knew so well how to embody the essence, landscape and light of the Empordà region. On leaving this space we once again find ourselves with Dalí. We can see lithographs of the series "Les songes drolatiques de Pantagruel" (1973) alternating with four cabinets, the first of which shows a montage with a Venus de Milo, an image that is repeated throughout our visit, and a classical figure that flanks a reproduction of the chair with spoons designed by the artist and crowned by an anthropomorphic violin. This installation, carefully put together by Dalí, is based on the rotating play, full of mystery, of the glances of the figures.

The second cabinet is dominated by a collage by Dalí, *Arab* (c. 1962), made from an appropriately retouched squid skeleton and a drawing that outlines a character of the painter over a collection of moulds, with a reed frame as a background. The third cabinet shows the oil painting *Tristan and Isolde* (1945), which was used for one of the backcloths for the ballet *Mad Tristan*, and a watercolour temple, a composition with table, drawers and different soft characters with inkpots, which, according to Dalí, provided a feeling of wellbeing and brought a smile to whoever looked at it, and of which there is another example in the bedroom of the Palace of the Wind. In the final cabinet there is a complex montage, in homage to an unlucky picador in the Figueres bullfighting ring who had to have his leg amputated, a reference made patent by the stuffed crocodile. The set is completed by a fragment of a polychrome Renaissance curtain.

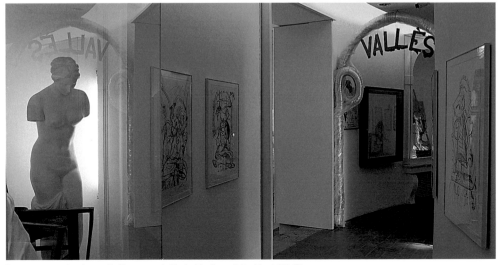

Passageway and entrance to the space dedicated to the painter Evarist Vallès.

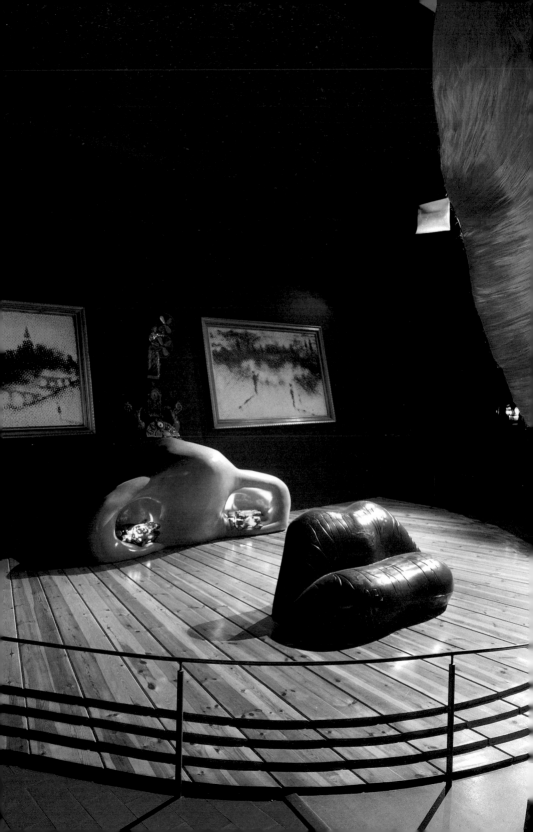

Climbing The stairs that go from the area beneath the cupola to the first floor, we come to the Mae West Room, one of the most popular in the Theatre-Museum, where we can take in the three-dimensional application, the creation of a room, from a two-dimensional image, the wash on newspaper of *Face of Mae West which may be Used as an Apartment* (c. 1934-35), by Salvador Dalí, that is on show in the Art Institute of Chicago. The painter, in a televised interview, stated: "Being Phoenician, instead of making a surrealist dream that you forget and which vanishes in just a quarter of an hour after waking, I have preferred to produce a dream that can be used as a living room. Therefore there is a chimney, and a mouth that is called saliva-sofa, where you can sit very comfortably. For the same price, we have enough space over the nose to place a clock of extremely poor taste, the kitsch of Spanish art, and, of course, on both sides of the nose, the two eyes, which are nebulous impressionist images of the Seine in Paris".

MAE WEST ROOM

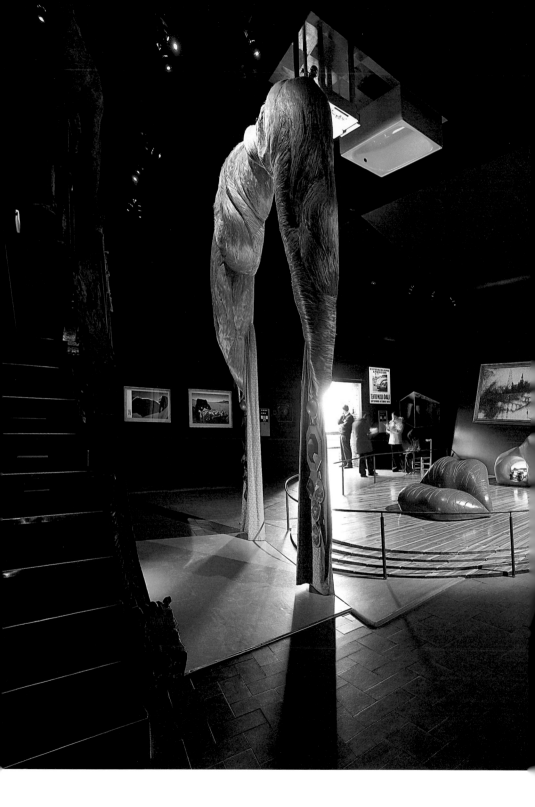

Mae West Room dominated by the popular three-dimensional assembly in homage to the North American actress.

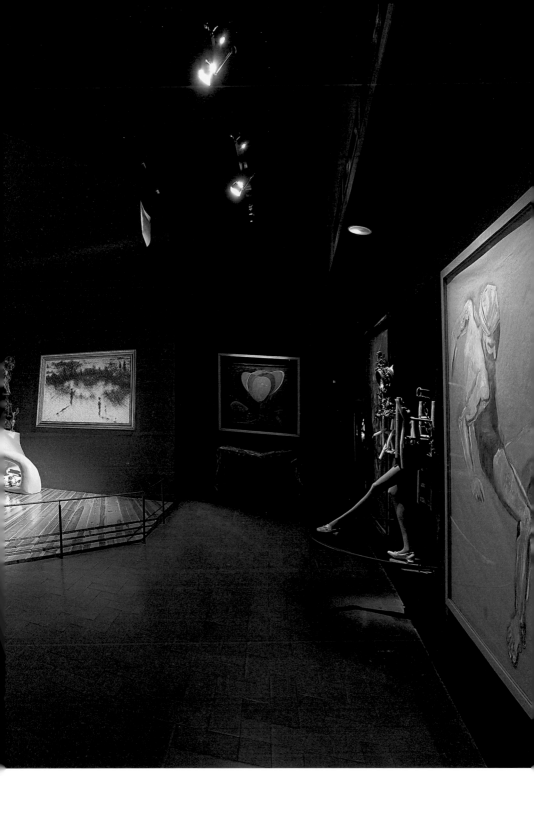

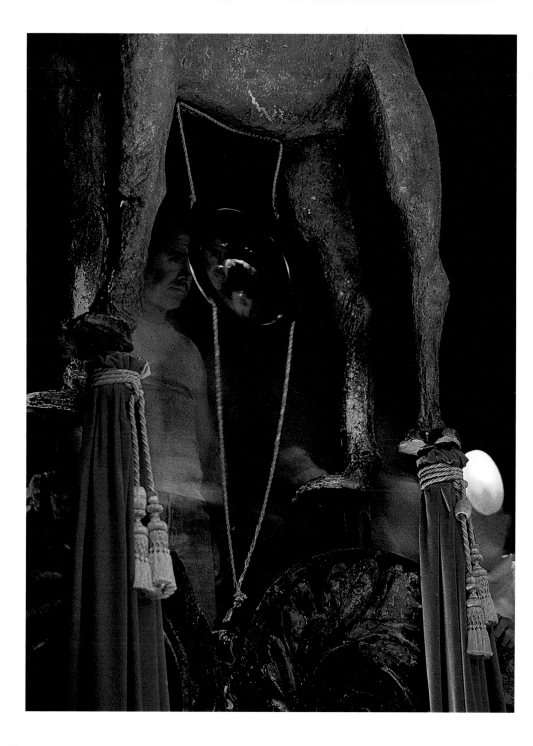

Reducing lens that hangs from the camel enabling the visitor to see
the face of Mae West in its totality.

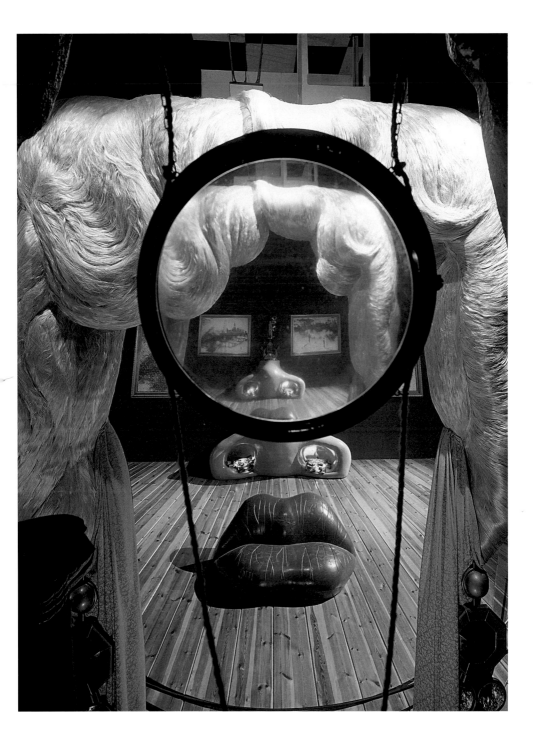

Photo taken from the top of the stairway that provides a view of the whole face
that we get from looking through the reducing lens.

Different installations in the Mae West Room.
Venus' Otorhinologic Head, 1964. →

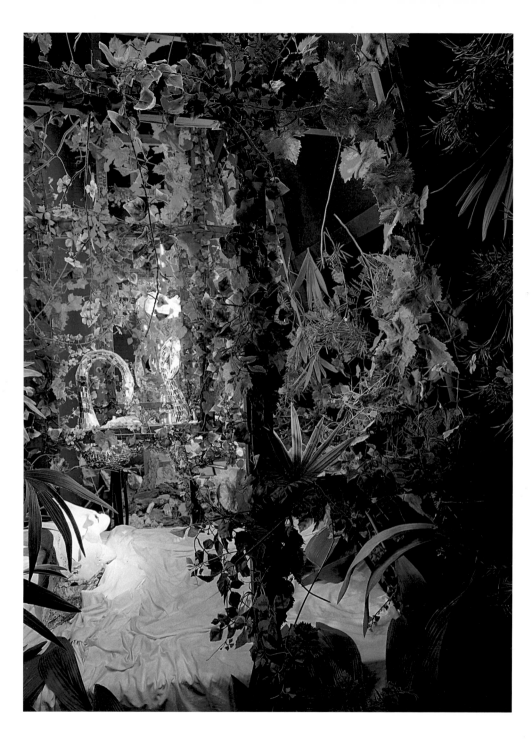

Installation called *Paradise*.

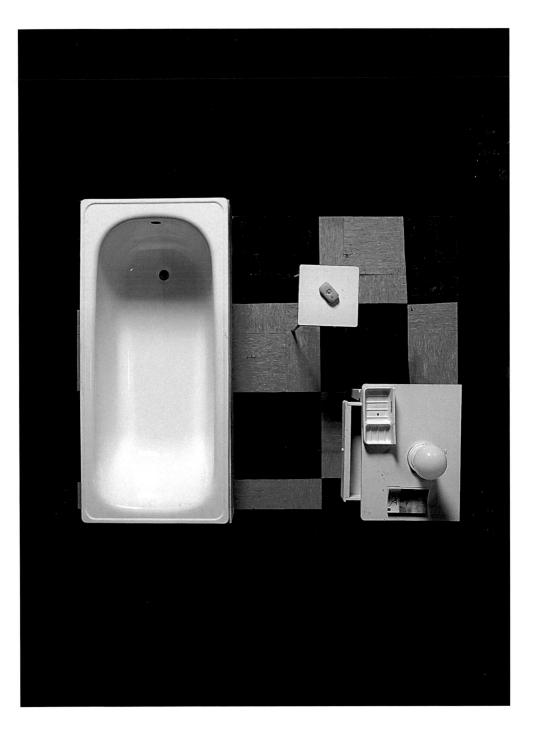

Upside down bath placed on the ceiling of the Mae West Room.

The project was undertaken with the architect Oscar Tusquets and the collaboration of the architectural technician Pedro Aldámiz. The eyes are retouched photographic enlargements of two pointillist paintings with views of Paris; the nose is a chimney with logs; the wig, included in the Guinness Book of Records, was made by Lluís Llongueras; and, finally, we must highlight the sofa-lips, the idea that Dalí developed as far back as 1937 and which was displayed in Paris in the shop of the fashion designer and friend Elsa Schiaparelli. Other elements of the composition are the fan-clock, an antique clock, two vases and a Venus de Milo with a giraffe's neck and drawers. To be able to perceive this optical play as a whole, the visitor must go up some stairs crowned by a camel, a gift from the Camel company, from which hangs the reducing lens that provides us with Mae West's face. We could even say that this is a forebear of pop art. If we look up we can see on the ceiling an inverted bathroom that Dalí decided to place in 1977.

In this room, Dalí pays homage to the hyperrealist painters. We should recall that in 1973 he published the preface titled *Realisme sybaritique aigu* in Linda Chase's book *Les hyperrealistes americains*. We can also see oil paintings by Silvère Godéré, a painter from Rouen, produced in 1975 at the specific request of Dalí, in blacks, greys, reds and sky blue. The first is a copy of the work by Evarist-Vital Luminais *The Enervated of Jumièges*; also on show is an original advertisement from the Canon company that Dalí had placed in an irregular position in reference to the silhouette of the boat of the enervated. According to Dalí, it was, in some way or another, about the same painting. A third oil painting by Godéré is the copy of the sleeve of a Duke Ellington record. Dalí wanted to mix the painting of Bouguereau and the hyperrealist in order to see the contrast between *pompier* and avant-garde painting. On the same wall is a pencil portrait of Dalí produced by Sebastián Cestero in 1975 from a photo.

There are then two works by Dalí in a niche. An oil painting on plywood —which given its size Dalí decided to install in this spot by pressure—, which represents a hairy Venus which, as if it were a fountain, suckles a cupid; and a shiny bronze piece from 1973 in the form of *Venus de Milo* with draws and a giraffe neck.

Beneath the stairs, we can see a pop montage of plastics and fabrics with Japanese figures and, on the other side of the stairway, an assembly with hippopotamus, violinist, discus thrower with an effect of a virtual mug and a real teaspoon, which we can also see in the corridor.

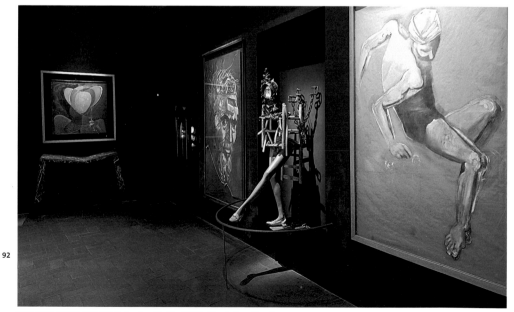

Side view of the Mae West Room with the 1926 oil painting *Head*.

On the wall facing the entrance is the sculpture *Venus' Otorhinologic Head* (1964) in plaster coloured white and sky blue, in a way of a monster or divinity, with the ear for a nose and the nose for the ear. There is then an oil painting on waxed paper of a male figure seated with his back to us, which had to go below the cupola, but which, given the subtlety of the contours, was not cut out; the sculpture *Chair-Mannequin* (1976), with elements such as chains and candles with a disturbing effect; another large oil painting, *Head of Michelangelo* (c. 1975), with a draw on the front and some filaments that sprout out of it; and, in a cabinet, a mask with a top hat with drawers designed and worn by Dalí at one of the fancy-dress balls held by the Rothschild family. It has four faces, two with versions of the Dadaist *Mona Lisa*, with moustache and goatee beard respectively, a third with the portrait of Helen Rothschild and the fourth for the person wearing the mask.

On the next wall, the oil painting by Dalí, *Head* (1926), in violet and earth-green tones, a face with its shadow from the series he produced after his visit to Picasso's studio in Paris; and the table designed for Bigas Luna, the well known film director, from the series "Nine broken tables" which, according to Dalí, were for eating sea urchins from.

Before leaving, on the right, we can see that the screen that closes the installation has two holes at two levels, for adults and children, so that the curious visitors can look through the opening and at the same time start one of those long queues that Dalí loved so much. In some ways, this work can be associated with the *Étant donné* by Marcel Duchamp, or with one or more installation by Dalí himself, above all *The Dream of Venus*, which he produced for the World Fair in New York in 1939. On the left, *The Trial of Mary Dugan*, another hyperrealist work.

On the wall leading to the exit, we see an op art photographic composition with a female figure, *Donyale's Tee Vee*, by Luigi Cazzaniga, and the poster for the American hyperrealism exhibition of the Daniel Hechter collection, which should have taken place in the Theatre-Museum but which was not eventually held. Dalí defended the American hyperrealists in order, according to him, to savour more his vengeance against abstract painters.

Returning to the corridor, on the right, we see an installation with the sculpture of an old lady dozing on her rocking chair —a work by Francesc Anglès— tied by a kind of red umbilical cord to the only unreal cube of the piece, the one painted on the ceiling, from where also appear some phantasmagoric heads with illuminated red eyes, references to the painter and friend from the Canary Isles,

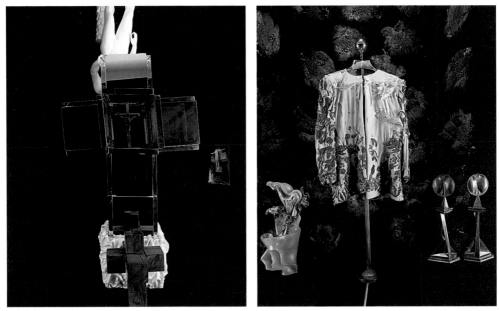

Two interiors of the cabinets created by Salvador Dalí.

93

and to Federico García Lorca and Néstor Fernández de la Torre. The huge light comes from the Casino Sport in Figueres, of which his father had been a member. Dalí used to say that he would be really famous when they spoke about him in the Casino of Figueres. There is also a standard made up of a loaf of bread and a sheep's head, the oil painting *Nymphs and satire*, a copy of a Bouguereau, and one of the anthropomorphic chairs that Dalí designed for the garden of his house in Portlligat. Passing through the arch, on the side wall, Dalí painted a series of titans on board, in the style of the giants with which Giulio Romano decorated the large rooms of the Tea Palace of Mantua.

Now in the corridor, we find ourselves before the first of a successive series of three cabinets with the bottoms lined with pheasant feathers. Outstanding here is the reproduction of *The Bust of a Retrospective Woman*, made in 1933, exhibited for the first time in the surrealist exhibition of the Pierre Colle Gallery in Paris the same year, and reconstructed with some variations in 1970. Remember that Dalí made a great contribution to the invention and importance of the surrealist object. To this bust the artists added ants, cobs of corn, a zootrope and a loaf of bread with a bronze inkpot on top with the characters from Millet's *Angelus*, so present in Dalí's imagery. A pedestal made up of a gloved hand in black that is intertwined with a white paraffin wax hand supports the sculpture. The composition of the cabinet is completed by the remains of a shark's jawbone and of a flying fish, the illusion of a plastic cup with a real spoon and the symbolic rhinoceros horn.

In the second cabinet, Dalí recreates a series of images with sumptuous will, where standing out over the base of pheasant feathers is a dress coat of Coco Chanel and the sculptures *Flower of Evil*, a Daum glass paste jar from 1970 with assemblies of a paraffin wax foot and another for the study of an anatomy class, and the two that make up the mythological Dioscuri, Castor and Pollux, sons of Zeus and Leda, the metal version of the engraving *The Immortality of Castor and Pollux* from the book-object *Ten Recipes for Immortality*.

In the third cabinet is a hyper-cubic cross, made up of a mechanical structure of mirrors with a Christ inside, which has joint movement; a reproduction of *Corpus Hypercubicus*, the 1954 oil painting exhibited in the Metropolitan Museum of New York; a classical sculpture of inverted plaster and headless, and a small hyper-cubic cross made from the wood of an olive tree.

We then come across a stained-glass work by Francis Gruber (1912-1948), which Dalí decided to place in his Museum when he was then living in Torre Galatea, and, following the corridor to the left, a small space where there are four plastic op art pieces —placed over drawings by Dalí, among which features the figure of the Virgin with Child—, produced with the intention of creating optical illusions. A massive oil painting on wood from the 70s, which refers to Botticelli's *The Spring*, with a light that filters through the foliage and the projection of a spectacular chromatic distribution over the character completed the space. If we carry on we can see lithographs by Dalí from the "Mythologies" series, as well as some of those he produced to illustrate *The life is a dream*, by Calderón de la Barca.

Now in the reception area of this floor, where the stairway leads to the two upper floors, there is a cabinet on show that houses a *Venus de Milo with drawers*, a reproduction of the plaster original from 1936, designed by Dalí and produced by Marcel Duchamp. It is a copy that belongs to a series made in 1964 that he had done in bronze buffed with plaster. In an interview in 1970 in "La Actualidad Española", Dalí asserted: "The Venus de Milo represents a world of external turgidity, to which I add what Christianity and Freud have added: within the platonic body I introduce drawers and compartments with elements of the subconscious, guilt, mental perfection, faith, hope and vertical and horizontal charity, and especially surrealism".

Bust of a Retrospective Woman, c. 1974 copy of the one produced in 1933 and exhibited at the Pierre Colle Gallery in Paris the same year. →

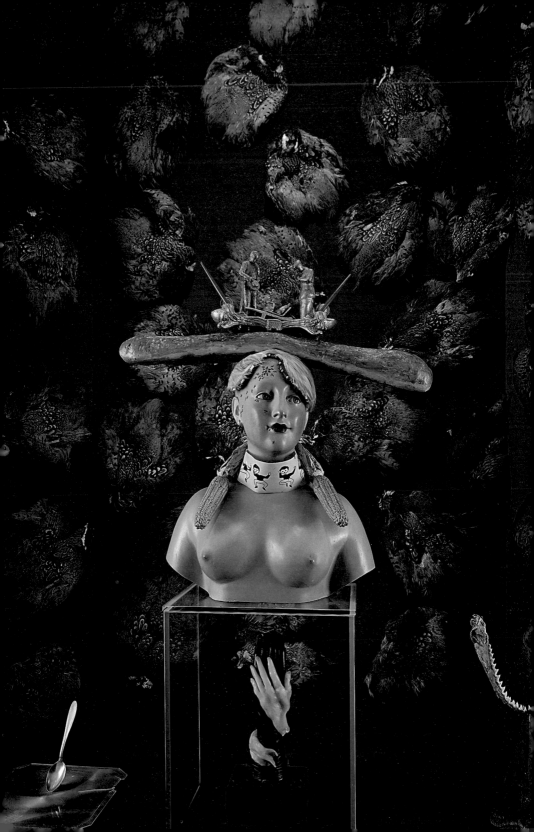

On the stairway, with a rhythmic presence, twelve engravings accompany us from the "Carceri d'invenzioni" series, known as "The Prisons", by the 18th-century Italian architect and engraver Giambattista Piranesi, in facsimile edition in the National Library of Paris. Dalí was particularly interested in the fantastic scenes and mannerism of these engravings, which describe a syncopated, labyrinthine and confused space. The walls of Piranesi's prisons reminded Dalí of those of the Theatre-Museum before restoration. Dalí thus emulated Leonardo da Vinci and Piero de Cossimo since they both recommended looking at the irregularities of the walls, which were often a source of inspiration.

In the centre of the spiral stairway, covering the central lamps, are the fancy dress costumes of the Dior company when Pierre Cardin worked there, and which Dalí and Gala used at the fancy-dress ball held by Carlos de Beistegui in the Labia Palace in Venice. A photograph of this ball is on view at the beginning of the stairway, before *the eagle* by Valls. These costumes also have connotations of Spanish-inspired scenography, for example *El sombrero de tres picos* [The three-cornered hat], with its covert characters with three-cornered hat, skull and delicately tied costumes.

On one of the stairway landings, after the second floor and the anthropomorphic mouth that is the entrance, is the character produced *in situ* on expanded polystyrene with plaster and of one single feature, with a mask, shell and supporting a broken column with drape. Continuing our tour towards the masterpiece room we come across a silver head, similar to those of Castor and Pollux that are in his house at Portlligat, also installed on a black expanded polystyrene surface. Finally, we can see a very large format oil painting, *Cybernetic Odalisque* (1978), produced from an anaglyphic diagram by Bela Julesz, an American scientist of Hungarian origin, an expert in the perception of the third dimension. This painting corresponds to the series of paintings that Dalí created in line with the latest research in optics.

SECOND AND THIRD FLOOR

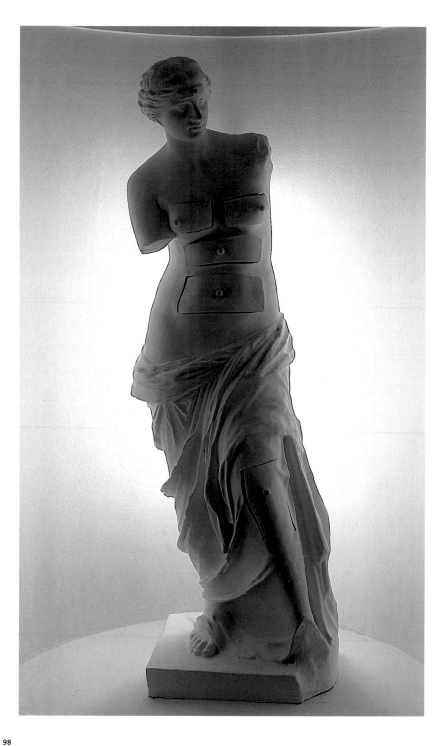

Venus de Milo with drawers, 1964.
Fancy dress designed by Dalí and the Dior company, 1951. →

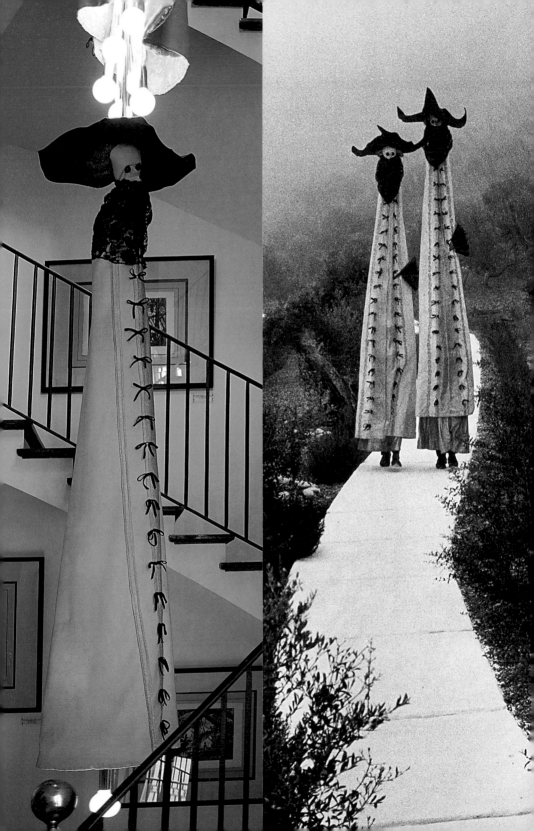

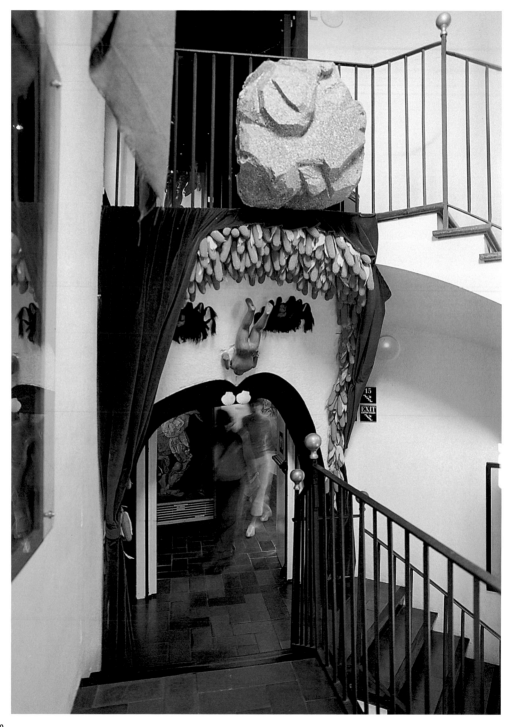

Anthropomorphic face that leads to the Antoni Pitxot room.

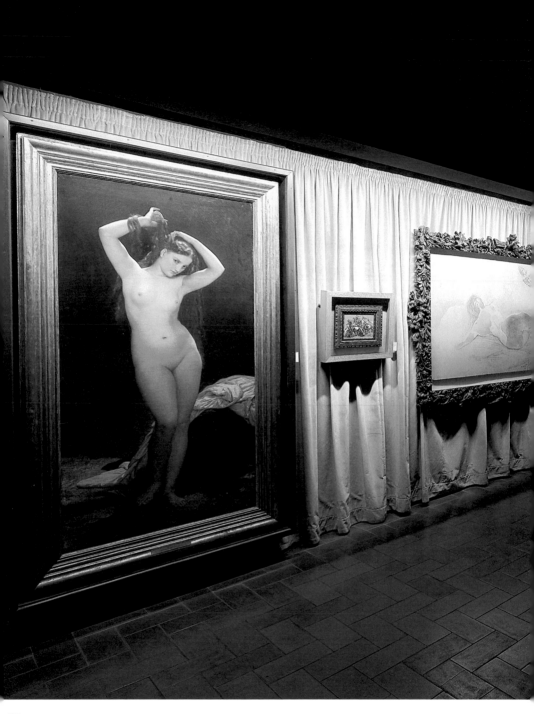

Masterpiece room with the *Female Nude* by Bouguereau in the foreground.

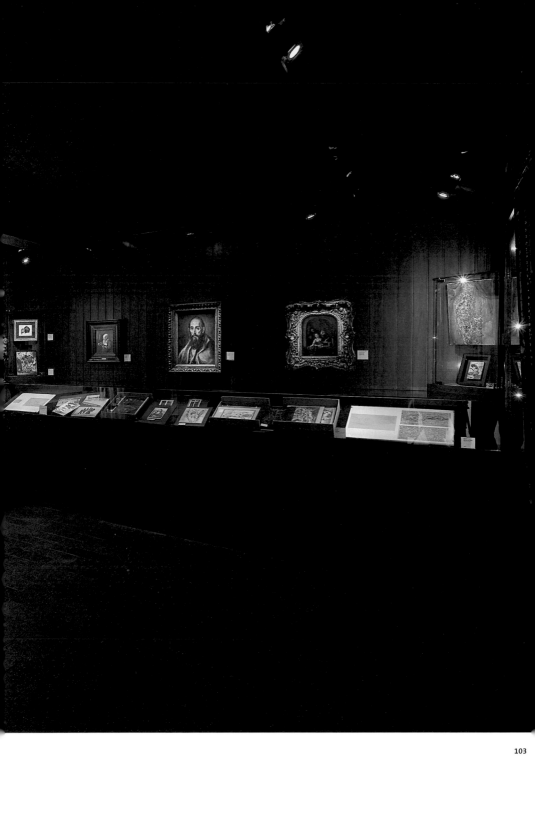

Now on the third floor, we can visit the Masterpieces Room where, with intentional chronological disorder, we can see some pieces of work that Dalí had collected over the years from different periods and by different artists, along with some of his own creations that the painter qualified as "timeless masterpieces". All of them together make up a play of aesthetic and intellectual perceptions that introduce the visitor into the creative genius of Dalí, the reason behind the Theatre-Museum itself.

We can highlight an oil painting by El Greco (1542-1614), *Saint Paul*, flanked by two works by Gerard Dou (1613-1675), *The Doctor's Visit* and *The Spinner*, also known as *Portrait of Rembrandt's Mother*, according to Dalí, "two probable stereoscopic experiences", since he considered this Dutch painter, a disciple of Rembrandt, as a pioneer in this type of experimentation. About the first painting, Dalí said that if a detailed analysis of the work is made we could see a possible skull inside the flask that the doctor is looking at, the symbol of death. Two small paintings attract our attention: *Portrait of Napoleon* and *Study of Soldiers*, examples of *pompier* art, by the academic painter Ernest Meissonier (1815-1891), often defended by Dalí for his passion for exactitude and true detail, and who he called the master of photography in colour and in hand. There is also a work by Adolphe William Bouguereau (1825-1905), *Female Nude*; two by Marià Fortuny (1838-1874), *The Stamp Collector* and *The Trial of the Alhambra* —as Dalí stressed, Fortuny confirmed in a letter that it was one of his favourite paintings—; two by Modest Urgell (1839-1919), *Cemetery*, solemn, expressing loneliness, and *Untitled*, an alley at night that Dalí thought to be one of the painter's best works. Also on show is an example of the well-known *Boîte en valise,* by Marcel Duchamp (1887-1968), friend and Dadaist artist. There is a considerable presence of Duchamp in the Museum, even in its origin, because the Theatre-Museum can also be considered as a big *ready-made* piece. From *Boîte en valise*, a type of foldaway catalogue that contains reproductions of works of art, dedicated to Gala and Salvador Dalí, who wanted to show it unfolded in a cabinet in total disorder, we can mention the image of the *Mona Lisa* with moustache, with the suggestive inscription L.H.O.O.Q. The painter from Figueres explained regarding this creation that it had suffered an, "ultra-intellectual attack perpetrated by the Dadaist movement. Marcel Duchamp, in 1919, drew a moustache and goatee beard on a reproduction of the *Mona Lisa*; and below, sketched the famous inscription L.H.O.O.Q. ('she has got a hot bum')".

Boîte en valise, 1958 by Marcel Duchamp.

Among the "timeless masterpieces" by Salvador Dalí, is exhibited the unfinished *Automatic beginning of a Portrait of Gala* (1932), a meticulous analysis of Gala's face, the same that appears in the drawing *Paranoiac Metamorphosis of Gala's Face* (1932) **[C16]**, or *Portrait of Gala with Two Lamb Chops Balanced on Her Shoulder* (1933) **[C17]**, the oil painting that, according to Dalí, unites the two things he loved the most: lamb chops and Gala. Dalí, in his text *New York salutes me*, asserted: "In those clear autumn afternoons in Portlligat, I had the custom of placing two grilled pork chops balanced over Gala's shoulders and, seeing the movement of the tiny shadows produced by the accident of those chops on the flesh of the woman I love, while the sun set, it was how I finally achieved sufficiently lucid and attractive images to exhibit in New York". Two 1956 oil paintings, both from the painter's nuclear-mystical period, accompany the previous ones, *The Hunter* and *Saint Surrounded by Three Pi-Mesons*, the latter inspired by science, and by nuclear energy and the pi-meson in particular. We can also see *Dalí from the Back Painting Gala from the Back Eternalised by Six Virtual Corneas Provisionally Reflected by Six Real Mirrors* (1972-73) **[C44]**; on the first floor we can see two other versions, of the same name, that form a stereoscopic piece; or the drawing, with clear references to *Venus of the Mirror*, by Velasquez, *Preliminary study of Gala for the painting "One Hundred Thousand Virtual Virgins Reflected by a Number of Real Mirrors to be Determined"* (1974). Finally, an oil painting that is often exhibited in this room called *Copy of a Rubens Copied from a Leonardo* (1979), a speculation of Leonardo-like forms and gestures that fascinated Dalí, since he said that in this composition of a battle it was very difficult to discern who was killing who.

Leaving the Masterpiece Room, to the left is the entrance to the corridor that rings the theatre stalls courtyard, which Dalí inaugurated and signposted with a street sign from Cannes, Rue Trajan, as homage to the Roman emperor who, according to the painter, sowed the seeds of Europe on conquering Dacia. This plaque is surely another reference to those that had been in the International Exhibition of Surrealism in 1938, also with names of streets and passages. There is then a plaster reproduction of *Michelangelo's slave*, painted black and with a horse's harness, which leads to a gallery, also all in black, where different pieces have been shown, even though since 2004 the magnificent drawings that accompanied his autobiography *The Secret Life of Salvador Dalí* have been on

View of the corridor where the drawings from *The Secret Life of Salvador Dalí* are exhibited.

show, which enables us to capture the main keys of Dalí's life and work. We can also see that drawing served the artist not only for purposes of mere illustration, but also as an essential tool to continue narrating his memoirs and to show us how Dalí gradually approached the ideals of tradition and of the Renaissance from a vital standpoint of active and persevering searching.

Now in the corridor, on the left, the first window is defined by the silhouette of the character that appears in his oil painting *A Couple With their Heads Full of Clouds* (1936), which is deposited in the Boijmans Van Beuningen Museum in Rotterdam, an installation which, in this case, converts the desired image into a real one since from the entrance to the corridor one can make out the clouds inside the silhouette and the spectacle of the Theatre-Museum.

On the right-hand side of the corridor, in one of the niches, appears *The Fly*, a singular iron sculpture enwrapped with mosquito net, which makes it more disconcerting and imprecise; and at the end of the gallery, the large window allows us to see a part of the spectacle of the Museum. It was one of Dalí's favourite viewpoints, from where one can see the sacks that recall the International Exhibition of Surrealism that he presented in 1938 in Paris, according to an assembly by Marcel Duchamp and which he announced as "Plafond chargé de 1.200 sacs à carbon". One can also see the plaster sculpture of Dr. Anglès, which represents an old woman dozing in her rocking chair; a copy of a work by Bourguereau, *Nymphs and satire*; and a kind of anthropomorphic plaster hammock, in the form of a skeleton, that had been in the painter's house in Portlligat. Dalí often stated that the view of the stage from the windows was one of the pleasures that the Theatre-Museum provided.

Going down again to the second floor we come to what is called the Antoni Pitxot Room Dalí's relationship with Antoni Pitxot went a long way back, from the friendship between both families. The painter wanted the "Pitxot" exhibition to be inaugurated jointly with his Theatre-Museum and that it would be a permanent exhibition on the second floor. In this space we can see oil paintings and some drawings by Pitxot from the period covering 1972 to 1989. Both Pitxot and Dalí had had, though with a difference of thirty years, the same art teacher: Juan Núñez Fernández.

Dalí stated that the view over the stage from the windows was one of the pleasures that the Theatre-Museum provided.

The entrance to the room is an enormous anthropomorphic face —at the behest of Dalí and produced jointly by both artists— with the dolls for eyes, the headless doll as a nose, the head of hair formed by cobs of corn and a large scenographic stone placed over the head.

When we enter into the reception area, on the left, is the oil painting titled *Mnemosine*, mother of the muses, who with her gesture invites us to come in. Opposite, we come across two *Self-portraits*, with mineral textures, made from the faithful contemplation of an anamorphic montage of stones, with Archimboldesque reminiscences, and a standing character made up of stones and lichens, that represents the figure of Saint George. The impressive oil painting *Allegory of the Memory* **[C55]** occupies a precise spot at the end of the left-hand corridor on the second floor. The three characters that make up the work can be linked to a passage from the *Libro de contemplación*, by Ramon Llull, which describes the three powers of the soul in the following way: "The first recalls what the second understands and the third wants. The second understands what the first recalls and the third wants. The third wants what the first recalls and the second understands". This is the iconographic key represented in the three characters: memory, understanding and will. At the other end of the corridor, on the right, there is a small room upholstered in red where important works of the author are often shown, such as *Day and Night*, which takes place in the caverns of the memory, at the entrance of which is *Mnemosine* with the light outside and, below, with the presence of the night, the darkness, and a series of mineral female figures. In the rest of the corridor we find combinations relating to *The Tempest* by the Venetian painter Giorgione, oil paintings that Pitxot created at the behest of Dalí based on the many conversations they had about the enigmatic work of the Renaissance painter.

Dalí, on opening the Museum, stated in the *Diario de Barcelona*: "...Pitxot represents fanatical love, the fetishism of the rocks of Cap de Creus, those which he reproduces with a kind of hy(pe)rrealism and total fetishism...", and it is in this spirit that we should contemplate the compositions of Antoni Pitxot.

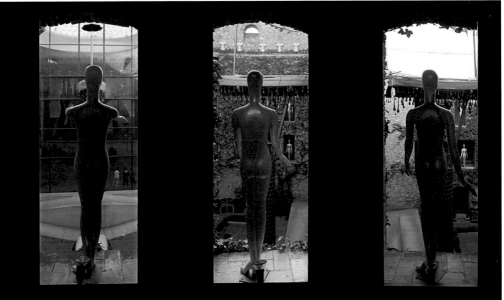

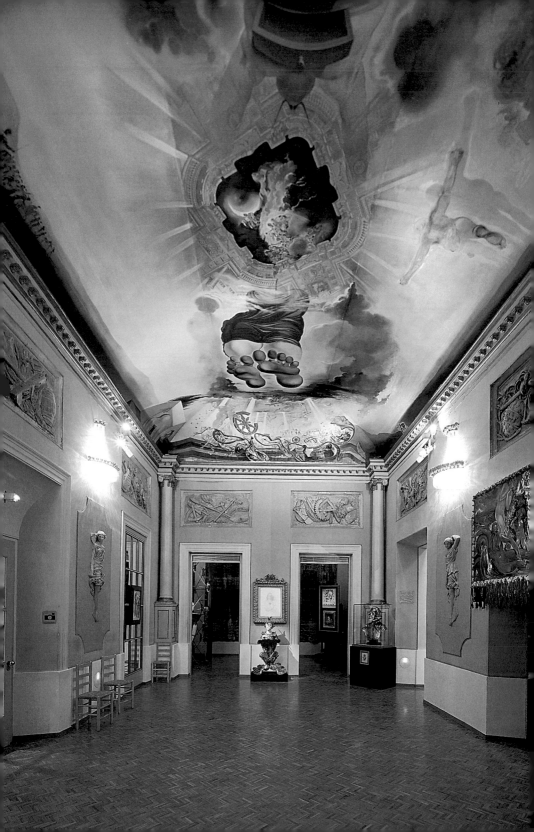

Salvador Dalí felt a special fondness for this spot since it was here in 1919 that he had his first exhibition, at the tender age of fourteen, sharing the space with another two painters from Figueres, Josep Bonaterra Gras and Josep Monturiol Puig, and he was given very good reviews by the local press.

This room is dominated by the impressive ceiling painting from which it gets its name. Dalí explained that this work is a paradox because when people look up they see clouds, the sky and two suspended figures, whereas in fact, it is a theatrical special effect, since instead of the sky you see the earth and instead of the earth, the sea, represented by the divine form of the Bay of Roses; and he added that in the centre of the sun one can see a hole with the darkest night, and from the deep human subconscious of the dark night of Saint John of the Cross emerges the submarine of Narcís Monturiol, which will be seen from the autogiro of La Cierva, the other inventor of a mystical device.

PALACE OF THE WIND

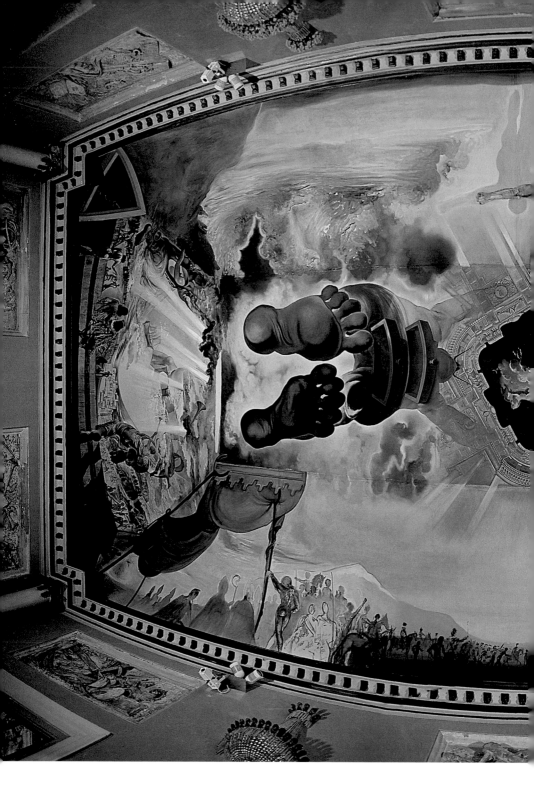

Impressive painted ceiling: *Palace of the Wind.*

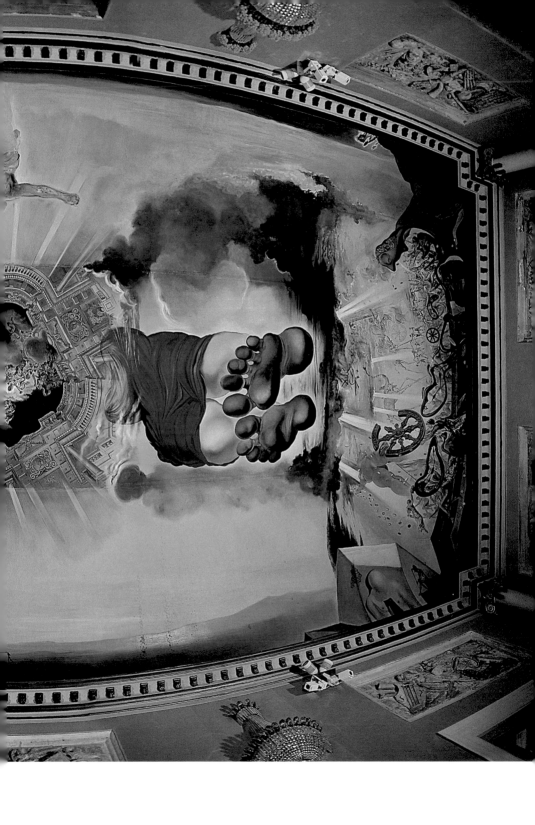

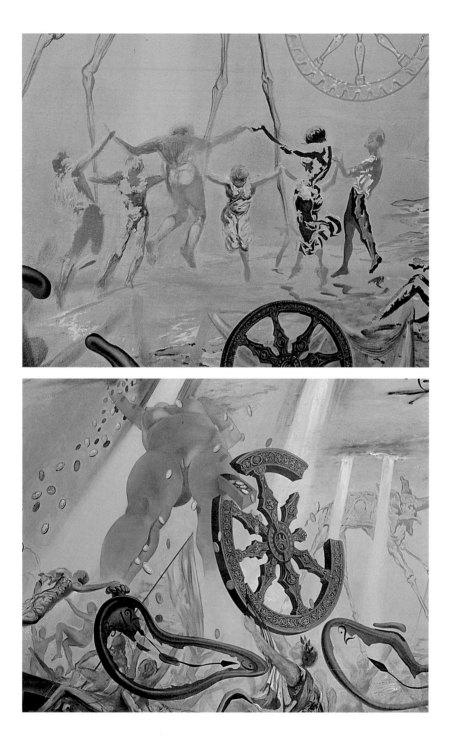

Ceiling of the *Palace of the Wind* with very meaningful elements of Dalinian imagery.

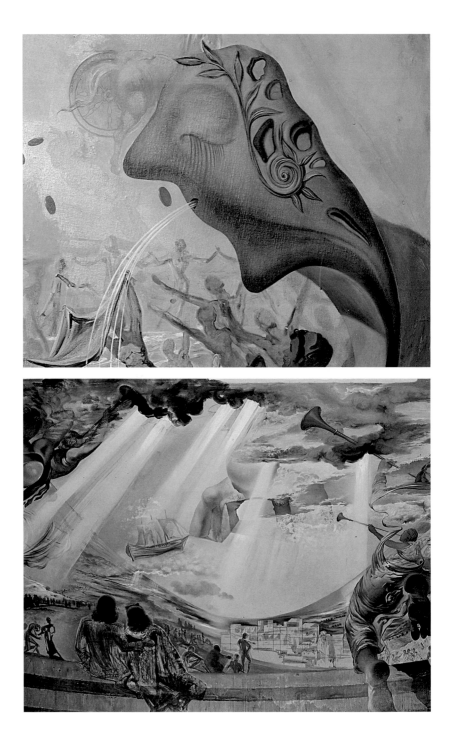

Alexandrine warrior by D'Alonso with platform made up of two back to front Victories of Samothrace.

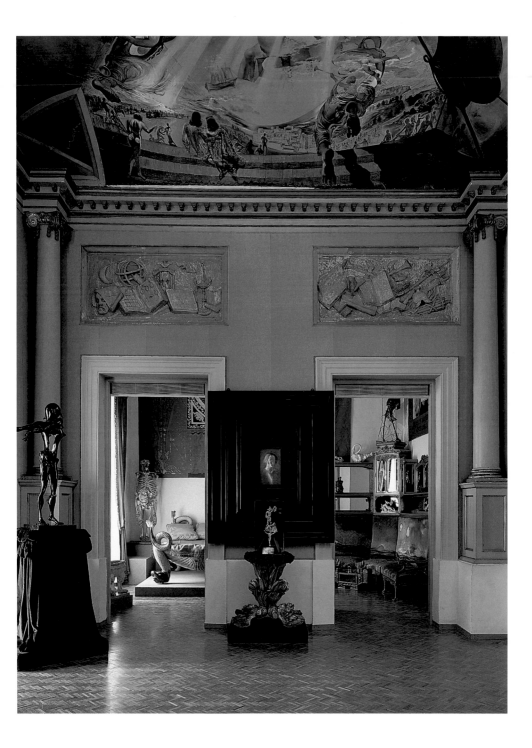

The Self-portrait overlooks this area.

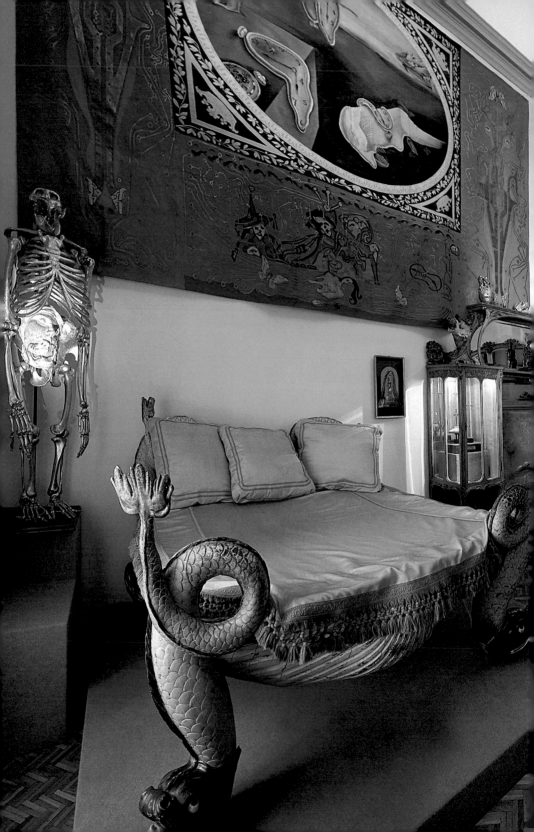

Back of the modernist sofa-cabinet painted by Dalí and diverse sculptures of this area, the bedroom.

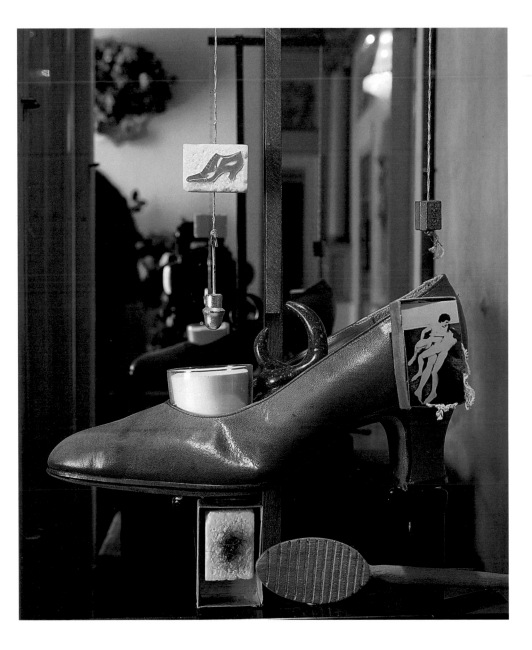

Surrealist Object Functioning Symbolically, from 1931, rebuilt in 1974.

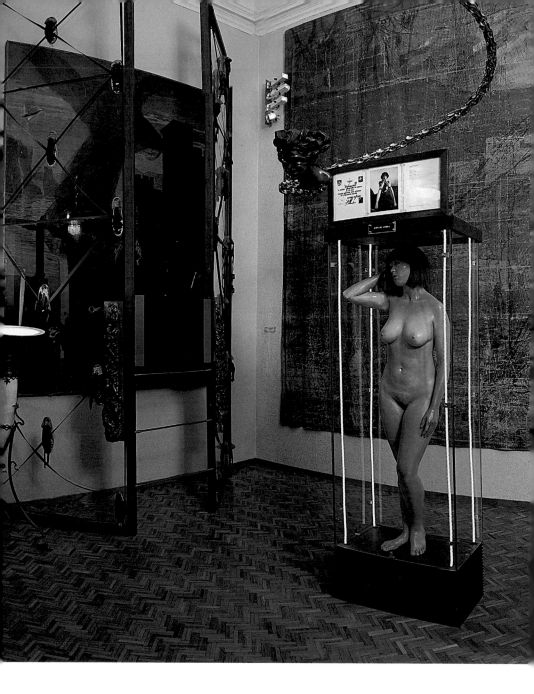

The studio, located to one side of the *Palace of the Wind*, a space dedicated to the eternal female.

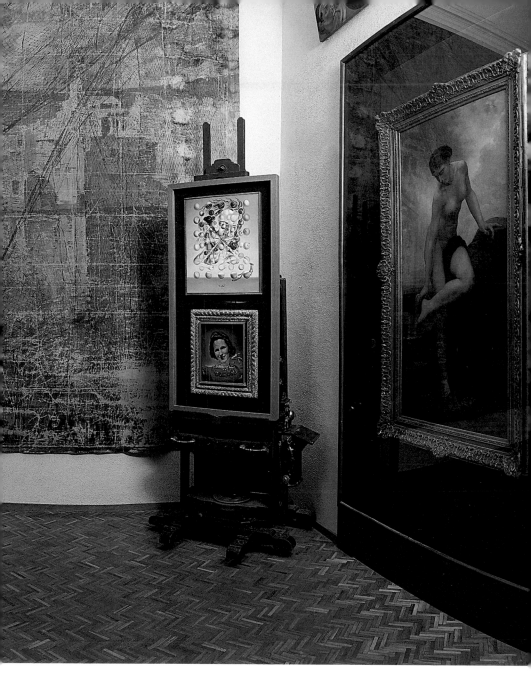

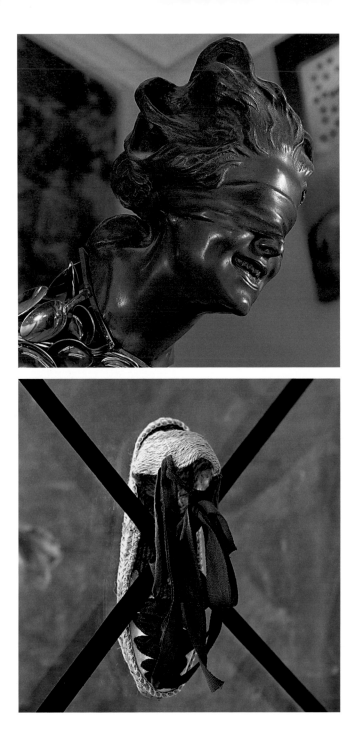

Two details of some elements from the studio.

Once again in the first floor reception, on our left we see two lithographs from the "Life is a dream" series to illustrate the book by Pedro Calderón de la Barca, and a drypoint engraving, a 1970 portrait of Picasso titled *Moi aussi j'ai connu l'empereur*. Continuing along, we come to the entrance door of the room called the Palace of Wind, the rest room of the old municipal Theatre of Figueres. The name comes from the Catalan poet Joan Maragall, who christened the Empordà county with the name "Palace of Wind", in reference to the Tramontana, the wind that blows in this area, famous for its great strength. According to the painter, this room represents his apartment: on the right, the bedroom, on the left, the studio, and in the centre, the room with its works.

The ceiling is really spectacular, decorated with five different canvases that Dalí painted in his Portlligat studio and which, once placed on the ceiling, were installed *in situ* from a specially built scaffold. In the central part we can see the foreshortening of Gala and Dalí, two colossi, and in the tradition of his early surrealist paintings, the artist is a kind of cupboard with open drawers upside down that pour out their rich contents: a shower of gold, both spiritual and material, over Figueres, the Empordà and, of course, over the spectators. On the right, Gala and Dalí reappear —in the style of *The Embarkation for Cythera*, by Watteau, one of the paintings he had a fetish for— contemplating the boat at the end of the voyages. Dalí said that composition of the images in the work by the French painter, in a film sequence, was the matrix for *Nude Descending a Staircase*, by Marcel Duchamp, another sequential image, with simultaneousness and disassociation of the forms. On the left-hand side, we can trace an extensive part of Dalinian imagery: the character from the backdrop of *Labyrinth*, the Lulian wheel —Dalí declared himself a mystic and said that mystics have the passion of gold, just as Ramon Llull did—, the elephants with insects' legs, the soft clocks, the soft face of the great masturbator... We can also see on the ceiling a Christ without a cross and with his back to us, the silhouette of the photographer and friend, Melitó Casals "Meli", or some figures sketched in white that are the advance notice of the current King and Queen of Spain.

Before entering the bedroom, a small youthful *Self-portrait* (c. 1919) attracts our attention, in a sumptuous frame chosen by the painter, under which is placed an installation with two sculp-

Gallery of the *Palace of the Wind* area.

tural jewels designed by Dalí, *Perseus cutting the head of Medusa* and a Christ crucified without a cross; an oil painting on wood, almost a miniature, that is known by the title of *Path to Púbol* (c. 1970), and the base formed by two sculptures of the *Victory of Samothrace* joined and placed back to front.

From here we go to the bedroom area, which features the bed in the form of a shell that comes from the legendary Paris brothel Le Chabanais and which, it seems, belonged to La Castiglioni, one of Napoleon III's favourites; and, beside the bed, a sculpture made up of a gilded skeleton of a gorilla with a reproduction inside it of the head from *The Ecstasy of saint Theresa* (1645-1652), a sculpture by Bernini that is in the church of Santa Maria della Vittoria in Rome, and which was of interest to other surrealists, particularly Georges Bataille. To help understand this creation we can read some fragments from the *Mystical Manifesto*, which Dalí wrote in 1951: "The objective of mysticism is mystical ecstasy; ecstasy is reached along the path of saint Theresa of Ávila and by the successive penetration of Las Moradas (mansions) or spiritual castle". He later adds, "Aesthetically, through the fierce self-inquisition of the strictest, most architectural, most pythagorical and most extenuating of all 'mystical fantasy', the mystical artist must form himself, through the daily inquisition of these mystical fantasies, in a dermal-skeletal soul (the bones outside, the extremely fine flesh inside), like that which Unamuno attributes to Castile, where the flesh of the soul can only grow towards the sky: mystical ecstasy is 'super-happy', explosive, disintegrating, supersonic, undulating and corpuscular, ultra-gelatinous, because it is the aesthetic blooming of the maximum in paradisiacal happiness that the human being can ever experience on earth".

On the other side of the bed, we see a work that represents a Virgin with Child with op art effects and, in the cabinet, the *Surrealist Object Functioning Symbolically* (1931), reconstructed in 1974. Dalí, in the article "Objets surréalistes", published in December 1931 in the magazine *Le Surréalisme au Service de la Révolution*, classified it as "object of symbolic functioning (automatic origin)" and described it in the following way: "A woman's shoe, in which has been placed a glass of warm milk, in the centre of a ductile paste, the colour of excrement. The mechanism consists of sumerging a lump of sugar on which has been painted the image of a shoe, the aim being to observe the

Ten Recipes for Immortality, 1973.

disintegration of the sugar and, as a result, the image of the shoe in the milk. Several accessories (pubic hairs stuck to a lump of sugar, a small erotic photo) complete the object, accompanied by a box of sugar as provisions and a special spoon for removing pellets from inside the shoe".

The metallic bath, in which Dalí had given some interviews, also comes from the same brothel. Of note here are the zoomorph legs of the marble bidet and the bed, and Turkish shoe-cleaner's bench. Opposite the bed there is a work by Dalí that, as we have shown before and according to the painter, gives a sense of wellbeing and raises a smile from the spectator.

Over the bed is exhibited the tapestry with the reproduction of the work *The Persistence of Memory* (1931), which is on show in the Museum of Modern Art in New York, where we can see his well-known soft clocks, the object of many interpretations. In his autobiography *The Secret Life of Salvador Dalí* he describes Gala's reaction on seeing this oil painting for the first time: "I looked intently at Gala's face and saw in it the unmistakeable contraction of wonder and surprise. This convinced me of the efficiency of my new image, since Gala was never wrong on judging the authenticity of an image. I asked her:

– Do you think that within three years you will have forgotten this image?
– Having seen it once, I could never forget it".

On the right is a modernist sofa-sideboard, on the back of which Dalí painted the Empordà landscape. In the central body of the piece there are several sculptures among which features the Michelin *Bibendum* with the head of a gull or the *Bibendum* with the head and neck of a swan; a *Homage to Newton*, this one a small version; the 1973 reconstructed version in porcelain of his *Hysterical and Aerodynamic Nude*, Woman on the Rock (1934); the *Maternity*, or the modernist vase with Leda and the swan. Also of note here is the sculpture with the head of Christ embedded in the centre and a printed circuit chip. Over the sofa-sideboard, the poster that Dalí designed for the French national lottery in 1972, over which is placed the oil painting *The face of fortune*, also known as *Lulian Wheel*, and in which, in fact, in the green circle we can see the face of fortune, with the disturbing optical impact produced by the complementary effect of the red.

Leaving here, on the right, we come across the sculpture in bronze, now in large format, of *Homage to Newton*, and we can go from here to the gallery on the main façade of the building, known by the name of *Ten Recipes for Immortality* immortality, as the artist declared, is the final objective of all alchemical research. As soon as we enter, we find ourselves before a large photograph on canvas of who was at the time the Prince of Asturias, Juan Carlos, which served as the basis for a portrait that the painter did of the King of Spain. We can then appreciate the engravings

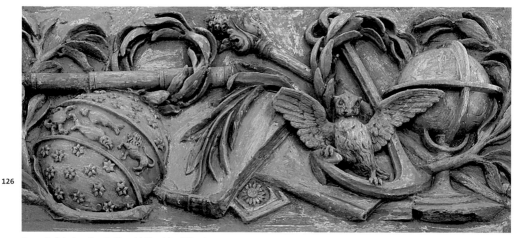

Bas-reliefs belonging to the old Municipal Theatre.

for the 1973 book *Ten Recipes for Immortality*, two of which are presented in stereoscopic format. At the end of the room is an installation with two cases of the luxury edition of the book, in which Dalí wrote *Immortality of genetic imperialism*, where he speaks at length on matters that interested him most at that time:

"Today the latest scientific discoveries show that the laws of God are those of inheritance contained in deoxyribonucleic acid, DNA, and which the ribonucleic acid, RNA, is no more than the messenger responsible for transmitting the genetic code, which is the *legi intimus* of two acids in question, in this way forming Crick and Watson's Jacob's Ladder. In Jacob's Ladder each rung is a DNA landing and the angels rise and descend along the RNA. The molecular intimacy of each rung is a unique rosette of legitimacy of this Tree of Jesse from which all other legitimacies are issued. Tree of Jesse, flowering of Francesc Pujols' hyparxiological immortality, recipe of Velasquez' immortality. This said, I can only hand over to the famous Salvador Dalí, who has explained once and for all how the emperor Trajan of Seville sowed the seeds of Europe on conquering Dacia, thus making it possible so that generations, imperially, *in aeternum*, would be able to differentiate themselves from kangaroos".

On the left-hand side panel, are exhibited lithographs from the series "Homage to Quevedo", which link up with a bas-relief bust of the writer, which belonged to the decoration of the old theatre, and below which Dalí placed one of his paintings, an oil painting on plywood from 1980, *The Machine that Thinks*, an accumulation of images, forms and sensations over which Dalí installed a chip from which comes a red string that rises up to the bust. In this way he pays special homage to Quevedo, who was the first to state that man is no more than a thinking machine, a qualification that we can apply to Dalí himself.

Leaving the gallery, in a cabinet, is the *Untitled. Bust of Velasquez Transforming itself into Three Talking Figures* (1974) **[C46]**, in which the image of *Las Meninas* stands out on the forehead of Velasquez. Between the two doors to the studio, where, according to Dalí, he combined the scientific with the artistic, there is an Alexandrine warrior in marble and gilded bronze, by D'Alonso, supported over a pedestal once again formed of two reversed Victories of Samothrace. Above, we can carefully observe the magnificent drawing *Study for "Galarina"* (1943) **[C28]**, where Dalí wrote very significantly a quote by Ingres: "Drawing is the integrity of art"; and one by himself: "Every line of a drawing must be a geodesy". It is an excellent example of Dalí the illustrator. On these lines, it is interesting to reproducea fragment of the preface for the catalogue of the "Dalí" exhibition in the Knoedler Galleries in New York in 1943, where the artists states:

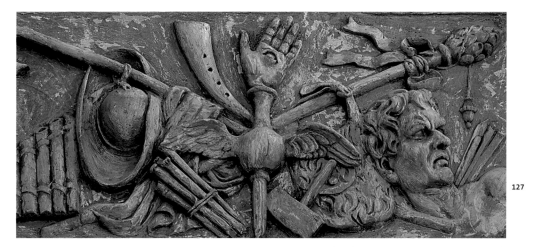

"In drawing, all my ambition has been limited to rediscovering the tradition of the old masters (...) Given that the technique reached the highest level of practice and perfection during the Renaissance, it is particularly evident, in our times of total decadence of the means of expression, that, on wanting to progress, we have to fatally go back. Before us, Ingres yearned passionately all his life to return to Raphael. In the same way Picasso follows the footsteps of Ingres with a scrupulous objectivity. A foot of Urbino sketched by Raphael, a face or a leaf outlined by Leonardo da Vinci are still, and will undoubtedly be increasingly so, the most exceptional and strangest miracle due to the sensitivity and intelligence of man".

Entering into the studio, there is a study for *The Hallucinogenic Toreador* (c. 1968-70), in which we can clearly see the double image with the toreador's face; beside it, *Female Nude*, by William Adolphe Bouguereau, considered an academic painter, *pompier* and, like Meissonier, defended by Dalí; above, the oil painting *The Golden Goat of the Castle of Quermançó* (1979), based on a local legend and in which Dalí represents the optical illusion of the gold coins. In the corner is an easel with a telephone, which had belonged to Meissonier, with two portraits of Gala: *Galatea of the Spheres* (1952) **[C35]** and *Portrait of Gala with Rhinocerotic Symptoms* (1954), from the mystical-nuclear period. In this space the artist shows the eternal female represented by Gala's face, the academicism of Bouguereau and the hyperrealism of the polyester nude by John de Andrea, placed right in the middle of the room. Above this sculpture our attention is attracted by a type of lamp with a modernist head of the goddess Fortuna that, with the eyes bandaged, snakes its way down from the ceiling on a chain of spoons overlooking the whole room.

The end wall is covered with a canvas, deteriorated by time, where you can make out the nighttime image of a fishing village, in this case Cadaqués, by the Catalan painter Eliseu Meifrèn. Beside it, an installation suggests an open window to us that frames the hologram *Holos! Holos! Velázquez! Gabor* (c. 1972-73) **[C45]**, in which Dalí, combining the most advanced concepts of science with traditional art, represents the dream of Velasquez, *Las Meninas*, with the third dimension. The installation comprises a large format oil painting with a romantic air by an unknown artist, two

Espadrille straps that frame the *Allegory of Spring*, 1978.

doors with a geometric pattern formed by espadrille straps and with a pair of large door handles with relief work. We then come across a modernist lamp by Hector Guimard and a pencil drawing by Dalí with nudes and sketched horses from 1972.

On leaving this space, once again beneath the painted ceiling of the Palace of the Wind, we can see two 1972 *sfumato* pieces, the technique invented by Leonardo. The first is of the face of Christ and the second, a female torso. On the other partition, inside the cabinet, are the costume and sword that he designed when he was named associate foreign member of the Fine Arts Academy of the French Institute and gave his speech *Gala, Velasquez and the Golden Fleece*, and the oil painting *Allegory of Spring* (1978).

Leaving the room, on the left, is another cabinet, this one dedicated to Millet's Angelus, represented by both a reproduction of the oil painting by the French artist and copies of the book *The Tragic Myth of Millet's Angelus: critical-paranoiac interpretation*. Dalí wrote this text while he was developing the mechanism of the paranoiac phenomenon from the surrealist point if view, in 1933, although, according to Dalí, he lost it and did not publish it until thirty years later. One of the different interpretations of Millet's work, expressed by Dalí in this book, is that the painting is a representation of the burial of the son, and to prove it he requested that the painting be X-rayed. It was then in the Louvre Museum, and, in fact, on the floor, between the couple, there had been a small coffin that the painter had repainted.

Next we come to the Poetry of America Room, where an important oil painting is on show of the same name and which was produced during his uninterrupted stay in the United States from 1940 to 1948. Dalí later gave it a second title, *The Cosmic Athletes* (1943) **[C27]**. Usually on show here too is the oil painting *Portrait of Laurence Olivier in the role of Richard III* (1955), as well as a magnificent 1974 drawing, *Angels Looking at the Celebration of a Saint's Taking the Holy Orders*. Now in the corridor, we can see lithographs from the *Mythologies* and *La vida es sueño* series, and on the left, we come across a door framed by croutons, like those on the façade of the Torre Galatea. It is the door that connected the old Torre Gorgot, now Galatea, with the boxes of the Municipal Theatre.

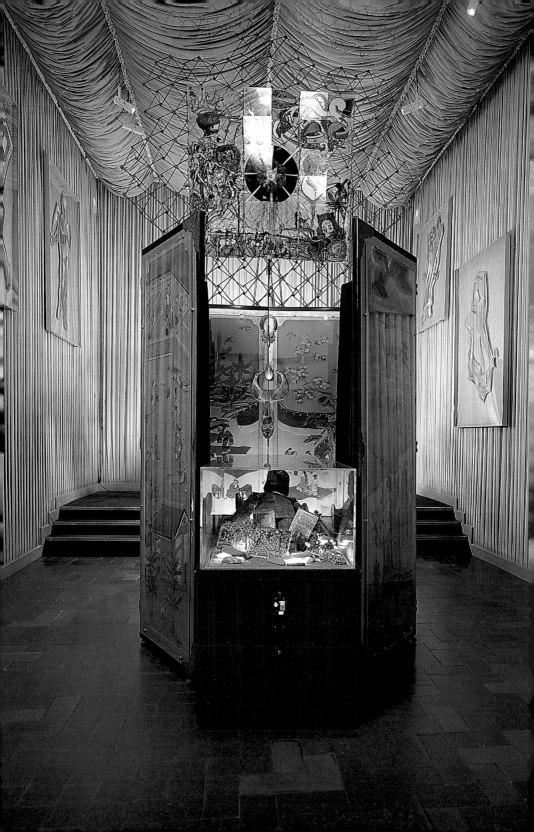

Before Going into the last room in the Museum, in the last section of the circular corridor, there is a space dedicated to monotheism, with the luxury edition of the book *Moses and Monotheism* (1974), by Sigmund Freud, illustrated by Dalí, and the replica of *Moses*, by Michelangelo, by the sculptor Frederic Marès, with an octopus and rhinoceros above, an assembly that for Dalí had the meaning of monotheism. In one of the upper arches we can see a figure representing Saint Sebastian and opposite a silhouette of Freud. Once inside the room, the large mobile central installation is before us: the deliberate darkness and the structure of Bramante's shrine with the jewels designed by Dalí inside.

We then enter Torre Galatea, the Museum's new extension, a more austere space and more in line with conventional museum protocol, where we can see the Optical Illusions Room —remember that from his childhood Dalí loved the effects related to sight— and the purchases made by the Fundació Gala-Salvador Dalí as well as the painter's last creations. It is in fact the artist's very last oil painting, *Untitled. Swallow's Tail and Cellos (Catastrophe Series)* (1983) **[C54]** that bids us farewell from the Museum and accompanies us towards the exit stairway.

TORRE GALATEA

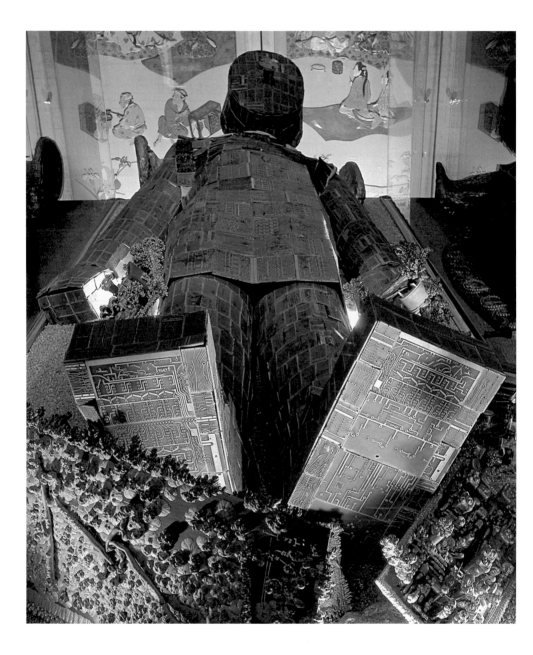

Cybernetic princess, made with printed circuit plaques and enwrapped by a folding screen covered in silk and oriental motifs.

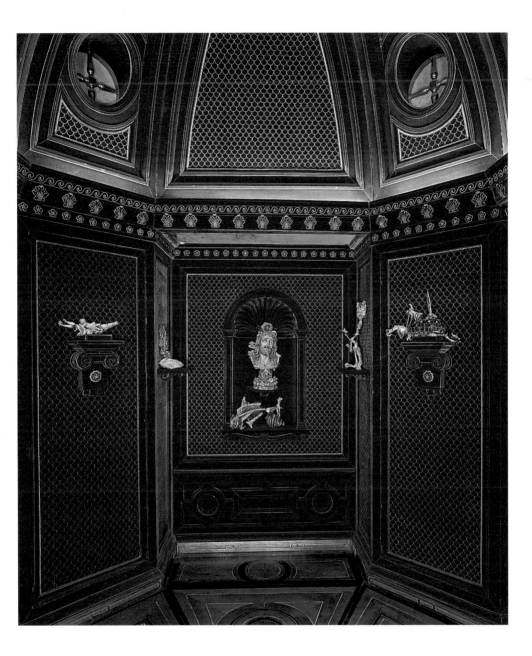

Replica of *Bramante's Shrine* where jewels designed by Dalí in the 1970s are exhibited.

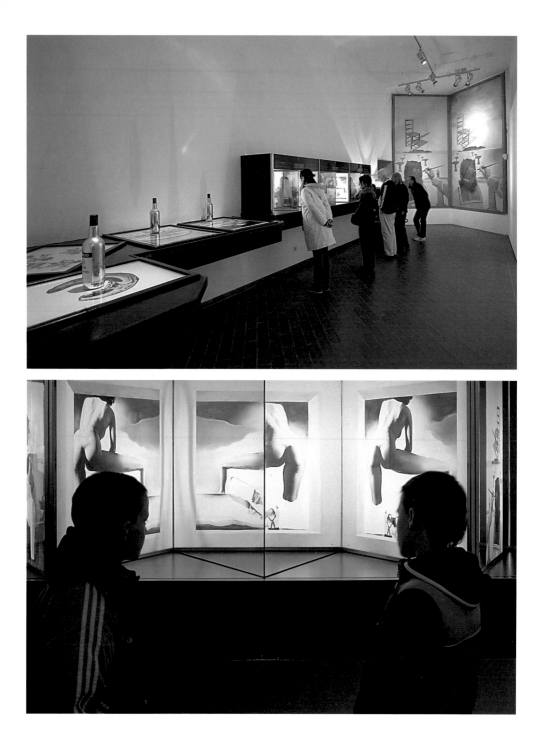

134

Loggia Room, dedicated to optical tricks: stereoscopes, anamorphises and holograms.

Dalí wanted the Bramante's Roman Shrine Room to be mysterious, which is why he decided to avoid natural light, covering the windows with a fabric that completely blocked out the outside light. In the centre is an imposing installation that is placed beneath a large foldable stained glass window, the result once again of the collaboration between Dalí and the architect Pérez Piñero. As we have mentioned, it is the reduced scale model of the stained glass window made up of 36 Methacrylate squares that, based on the *Discourse of the cubic form*, by Juan de Herrera, the constructor of El Escorial, and produced from a work by Dalí, he had to separate the stalls from the stage that would convert the Museum into a "holy cybernetic chapel". At the foot of the stained glass window is a funerary heart called *Cybernetic Princess*, with printed circuits that aim to emulate that of the articulated jade panels of Princess Tu Wan, from the II century BC, discovered in 1968 in the archaeological dig at Ling-Tong, in the Chinese province of Shanxi. The princess is surrounded by a folding screen covered in silk and with oriental motifs. On the walls we can see the originals of the Michelangelesque figures that were situated beneath the cupola.

At the end there is a replica, donated by the Chilean millionaire Arturo López-Wilshaw, of Bramante's Shrine —the original is in Rome. Dalí also called this space the "Arturo López lavatory". The floor is made of marquetry and a glass has replaced the front wall. On show in this shrine lined with velvet are jewels designed by Dalí in the 1970s, among which we can highlight the *Christ of Limpias* (c. 1970), a collage of amethysts over polychrome engraving with a painting by Dalí of the Empordà landscape in the lower part of the bust; *The Space Elephant* (c. 1970), *Madonna of Portlligat* (c. 1970), *Saint Narcissus* (1974) or *Trajan on Horseback* (1974).

From here we go to Torre Galatea, the Loggia Room: optical tricks and stereoscopes. Research into the world of optical illusions always had a philosophical conclusion for Dalí, the definition of images from the indefinite, which is time. His desire was to give substance to dreams, desires, fears and anxieties. He wanted the phantoms that accompany contemporary man to materialise.

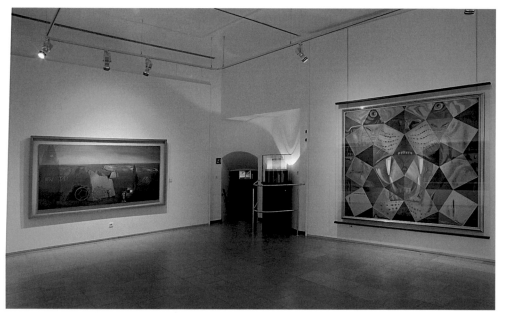

Second Loggia with the Tower of "All the Enigmas" in the background.

Since his childhood, Dalí had had a passion for the optical effects related to the sense of sight and, in order to obtain a special perception of the sensitive world, combined and adapted artistic technique with most advanced scientific technology of the time. Dalí, by means of different methods and systems —the double image, anamorphosis, stereoscopy, holography, photography, cinema—, always in accordance with the advances of science, represented external reality and, at the same time, inner reality, which might coincide or otherwise with that of the spectator, but which provokes in them a series of associations that enable them to eventually become immersed in the painter's discourse.

Dalí wanted to escape from the order and limitations created by the rules of optical experiment, and so, in the 1960s, worked on stereoscopy, a totally mechanical process in the optics of perception of the third dimension. In *Ten recipes for Immortality* he wrote: "Stereoscopy immortalises and legitimises geometry, since thanks to it we possess the third dimension of the sphere".

In this room we can see the stereoscopic montages with the oil paintings *The Chair* (1975), *Dalí Lifting the Skin of the Mediterranean to Show Gala the Birth of Venus* (1978) —exhibited during that same year in the Guggenheim Museum in New York and defined by the painter as a hyper-stereoscopic work according to the model developed by Roger L. de Montebello— and *Gala's Foot* (c. 1975-76), as well as the original oil paintings, two in each case.

We can also mention the 360° cylindrical hologram *Dalí painting Gala*, and in the next room, *Hologram dedicated to Alice Cooper*. Regarding his interest in holography, we can confirm that he was the first painter to undertake holographic experiments for purposes of purely artistic expression, and worked with this in mind in collaboration with the winner of the Nobel Prize for Physics, Dennis Gabor.

Once again in the inner room, on show are the four anamorphoses, four lithographs with images of a harlequin (*Harlequin*, 1972), a female nude (*Female Nude*, 1972), a rider with a standard (*The Horseman*, 1972) and a skull (*The skull*, 1972), which are made visible on a cylindrical and reflecting

"Quan cau, cau" Room with works from his late period.

surface, in this case a bottle of punch. Remember that Dalí had read the book by Jurgis Baltrusaitis, *Anamorphoses ou Perpectives curieuses* (1955) with great interest, and which in even the preface emphasises that: "Perspective is generally considered, in art history, as a factor of realism that restores the third dimension. Anamorphosis (...) reverses its elements and principles: instead of a reduction to its visible limits. It is a projection of forms outside themselves and their dislocation, in that they straighten up when seen from a specific point of view. The system is established as a technical curiosity, but contains a poetry of abstraction, a powerful mechanism of optical illusion and a philosophy of artificial reality". In this second room, that of the optical illusions, there are stereoscopic works and oil paintings such as *Homage to Meissonier* (1965), a sample of *action painting* with the appearance of Napoleon, another reference to the French painter; *Dawn, Noon, Sunset and Twilight* (1979) **[C48]**, or the significant *Searching for the Fourth Dimension* (1979).

Among the Foundation's acquisitions we can point out many works from the nineteen-thirties: *Figure and Drapery in a Landscape* (1934) **[C18]**, *Eclipse and Vegetable Osmosis* (1934), *Surrealist Composition with Invisible Figures* (1936) **[C21]** and *Average Pagan Landscape* (1937) **[C22]**.

On the right there is a small room that belonged to the old fortification of the city walls called Tower of "All the Enigmas", where the miniature theatre of *Babaouo* is exhibited, a scenic box with glass panels painted with oils that is based on the script by Dalí for the film of the same name but which he never produced.

We now go to the second loggia, in which, on the right, is the bullfighting publicity poster that was produced within the homage that Figueres paid to Dalí on the 12th of August 1961, with the collage of the drawing that he did himself for the cover of the menu for the supper-homage that closed that day's events. Now in the new room, on the right, we see the 1974 oil painting *Dalí Writing His Tragedy*, which shows Dalí the writer —we will recall that sometimes he declared himself a better writer than painter— writing, for sure, one of his last works, the tragedy *Martyr*.

Film shows in the courtyard of Torre Galatea on an August night.

In the Room that houses *Quan cau, cau*...(1972-73)**[C42]**, a Flemish oil painting repainted by Dalí in Portlligat between 1972 and 1973, there are works from his last period such as *Mercury and Argos* (1981), in which he develops the mythological history that also fascinated Velasquez. The meaning of the work refers to death or to the loss of life and its equivalent in the personal context of Velasquez, who chose this mythological theme to produce his last work. Dalí was fascinated in this myth, in which Mercury sends Argos to sleep with his music and then robs his ox and takes his life. We can also see *The Three Enigmas of Gala* (1982), with the profile of the Aphrodite of Knidos, horizontal, and with two seated figures representative of the passing of time.

And we end the tour with the 1983 oil painting *Untitled. Swallow's Tail and Cellos (Series on Catastrophe)* **[C54]**, in which he applied the *Theory of catastrophes* of the mathematician René Thom, with whom he maintained a friendship and exchanged knowledge. Other scientists with whom he was in contact were Severo Ochoa, Ilya Prigogine and Frank Salvan, with whom he dealt with on aspects regarding the first photographic image in relief of the gold atom on a silicon surface, which he had just obtained by means of tunnel effect electro-microscope, and which according to Dalí resulted in sinuosities like those of Bernini's columns.

After seeing this oil painting, we can go down the stairs that lead us to the exit, from where, on the right, we can get to the "Dalí. Jewels" space, or rather, through the glass door to the courtyard of Torre Galatea, from where we can see the bell tower of the church of Sant Pere and the museum walls. During August nights, when the museum is open, films in which the painter appeared are shown in this courtyard.

In his last stage, when he lived in Torre Galatea, from his bedroom window he often looked at the shapes that the sun created throughout the day over the walls of the Museum. In fact, in his last days, this was the only sight he thought worthy of contemplation and requested, something that has been fully respected, that this configuration never be altered.

Drinking a glass of cava from Peralada in the courtyard of Torre Galatea.

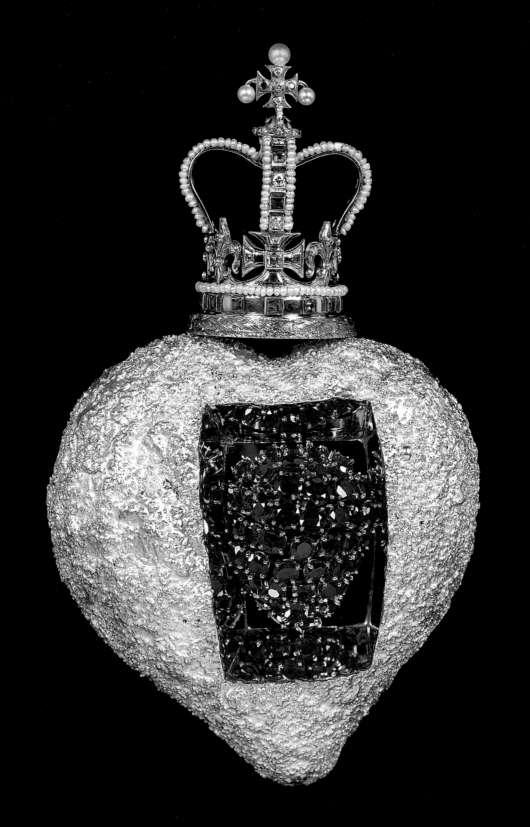

In 1999 the Fundació Gala-Salvador Dalí acquired the jewellery collection designed by Dalí that had belonged to the American Owen Cheatham collection, and decided to give it the space that had been the old Fonda Condal guesthouse in the city, later converted into an antique shop and later into the "new rooms" of the Theatre-Museum. The design of the room is by Oscar Tusquets and, in the deliberately darkened space, we are presented with both the jewels and the splendid preparatory drawings, which, during August and September 1973, in Dalí's lifetime, had been exhibited in the Dalí Theatre-Museum a year before its official opening. As the painter wrote in 1959: "The pieces adorned with jewels (...) were created to please the sight, extol the spirit, awaken the imagination and express convictions. Without a public, without the presence of spectators, these jewels would not fulfil the function for which they were created. The spectator, therefore, becomes the final artist. Their vision, their heart, their mind —which are fused and capture with greater or lesser understanding the creator's intention— gives them life".

JEWELS

Apotheosis of the Dollar, oil on canvas, 1965.

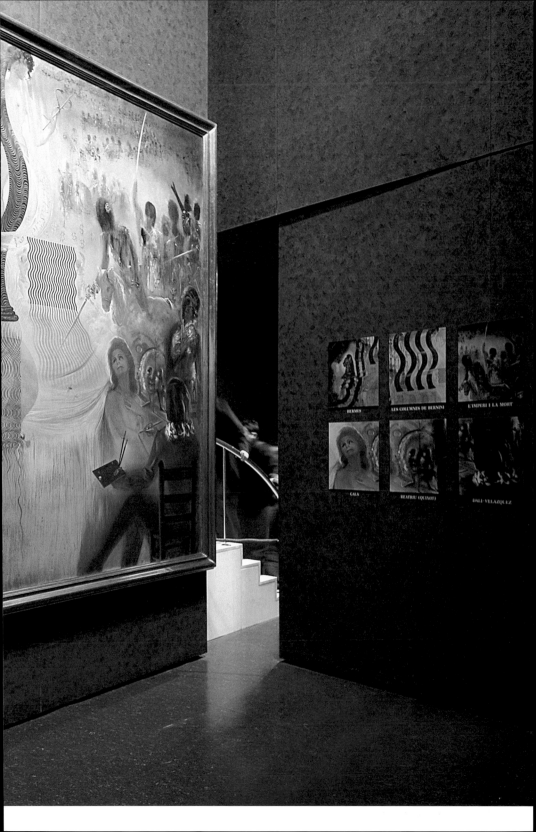

At the end of the room on the first floor, the entrance to the area, and near the stairway with mirrors that leads us to the second floor, we come across the 1965 oil painting *Apotheosis of the Dollar* **[C40]**, a compendium of the most meaningful images, the tendencies, the myths and the obsessions that accompanied Dalí throughout his life: on the left, the profile of Hermes by Praxiteles, with the figure of Goethe in the shadow of the nose and the portrait of Vermeer of Delft in the corner of the mouth; Marcel Duchamp, characterised as Louis XIV, with the lute player by Watteau over the head; on the right appears a Dalí-Velasquez painting Gala, at whose side appears Dante's Beatriz, which in a double image is a kneeling Quixote. Above, Napoleon's armies and, on the other side the soldiers from the Battle of Tetuan. All these images are structured from the Solomonic columns of the baldaquin in Saint Peter's of Rome, by Bernini.

The jewels make up a coherent, original collection and were produced by the New York jeweller's workshop of Alemany and Ertman. As Dalí explained: "I design, invent, imagine, like the great masters of the Renaissance, such as Rubens or Dürer, and when the time come to produce I put myself in the hands, as I have always done with very few exceptions, of the skills of perfect craftsmen, who I supervise".

The first jewels he created can be assigned to a surrealist stage, and the following ones to his mystical-nuclear stage, and the final ones include movement and mechanics. From the soft clock of *The Persistence of Memory* (1949) to the cross of *The Light of Christ* (1953) and the *Royal Heart* (1953) **[C36]**, a mechanical piece that beats.

These creations combine the craftsmen's mastery with the arts of sculpture and painting. To a large extent they are not jewels to be worn, and the precious stones are used as pictorial elements, except on the rare occasions when Dalí painted directly onto the gem. This is the case of *The Angel of Eternity*, which overlooks the jewels *The Grapes of Immortality* (1970), *Pax vobiscum* (1968), *Daphne* (1967) and *The Angel Cross* (1960), all of them jewels of added beauty.

The Dalinian symbology, to a greater or lesser extent, is ever-present in the jewels. The brooch titled *The Persistence of Memory*, which clearly emulates his famous 1931 oil painting, is the

"Dalí Jewels" Room.

clearest example; this clock, to which we could attribute so many meanings, was a constant throughout his creative work. The flow of life is also patent in *The Eye of Time* (1949), an eye that, in a distinct way and in collaboration with Luis Buñuel, was already immortalised in the film *Un chien andalou* (1929) and, years later, in 1945, in the film by Hitchcock, *Spellbound*. The symbol of the telephone, *Telephone Earrings* (1949), often appears in his work; here Dalí wants to show the technological advances made, the speed of modern communication and the danger of instant change of thought. The religious subject matter, represented above all by the cross, is of great importance in the jewels. Nor can we forget the references to ballet, evident in the jewel *Swan Lake* (1959); or the passion for visual effects patent in the necklace *The Tree of Life* (1949), in which, with a double image, we can see a woman's face. Also of note are the references to mythology, *Daphne and Apollo* (1953); to universal literature, *Ophelia* (1953); the Renaissance, Cellini, naturally, but also Paolo Uccello, *The Chalice of Life* (1965) **[C41]**; to the desire for immortality; the plant and mineral world and its anthropomorphic manifestations; the poetic-popular world, *Ruby Lips* (1949); or to modern times and technical and scientific advances, *The Space Elephant* (1961).

Finally, we cannot ignore some indirect references. In the sketches he made for the Dream of Venus Hall, which he showed at the World Fair in New York in 1939, he already showed sirens and female characters with original necklaces made from oysters. In the oil painting *Galarina* (1945) **[C32]**, exhibited in the Treasure Room, he shows Gala with a magnificent bracelet by Fabergé, painted with great craftsmanship and detail, which he also uses as a symbolic snake in the oil painting *Original Sin* (1941).In an earlier drawing, *Study for "Galarina"* (1943) **[C28]**, exhibited in the Palace of the Wind Room, Dalí describes the pendant that Gala is wearing in great detail. Moreover, around the same time, 1945, he painted the Portrait of Mrs. Isabel Styler-Tas, who wears a brooch with a character in the centre from which sprouts a tree and in the lower part, some pearls. When we look at the jewel *Daphne* (1967) we cannot forget the reference to this portrait: this idea of a pearl, or stone, suspended in space, evident in the oil painting by Dalí *The Madonna of Portlligat* (1950), we can also associate with Piero della Francesca.

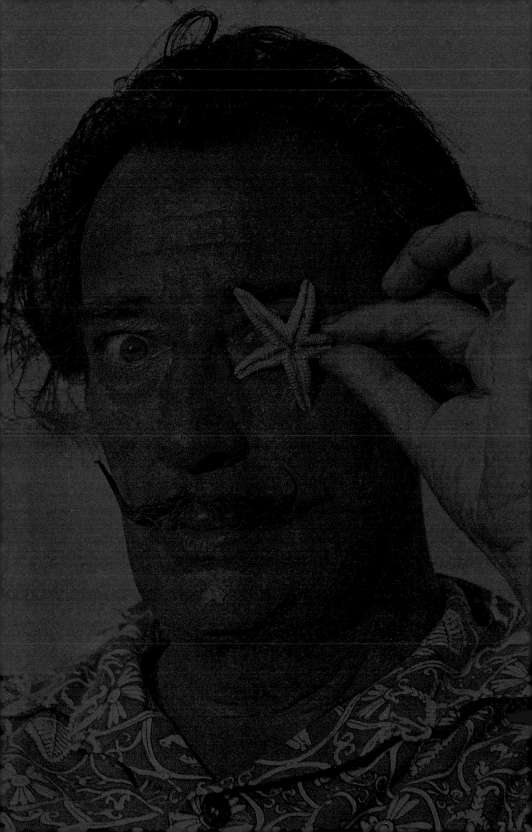

Here we present, in chronological order, a selection of the most outstanding works in the Dalí Theatre Museum, with a brief description of each one and the space where they are usually exhibited, although the position may vary according to exhibitional requirements.

CATALOGUE

[C1]
FIESTA AT THE HERMITAGE, c. 1921.
Temper on cardboard (52 x 75 cm)
Room 5 Fishmongers' Room

Temper from a period during which Dalí painted many landscapes, portraits and self-portraits. It is an early work, inspired by Catalan nineteenth-century art, particularly by the work of Xavier Nogués and Ramon Pitxot. It recalls a celebration in the hermitage of Sant Sebastià, a festival held on the 20th of January, the day on which the people of Cadaqués go the hermitage in a procession. This work demonstrates an aesthetic style closely linked to the ideas of Catalan culture and social and regional traditions that we also find in Catalan ceramic images, particularly on glazed tiles, so full of personality. On the other side is the temper *The Fair of the Holy Cross at Figueres*, which we date at around 1922.

[C2]
THE SMILING VENUS, c. 1921.
Temper on cardboard (51.50 x 50.30 cm)
Room 5 Fishmongers' Room

Dalí exhibited this work in the Dalmau Galleries in Barcelona from the 16th to 31st of January 1922, in the "Competition-exhibition of students' original works of art", organised by the Catalan Student Association. The critics of the time compared it with Giorgione's *Sleeping Venus*. It could also be, at the same time, the Dalinian version of Matisse's Luxe, *Calme, et volupté*. Dalí used a pointillist technique, common in his time, which he had seen in the works of Ramon Pitxot in El Molí de la Torre, the estate that the Pitxot owned near to Figueres. Dalí provides ironic notes, such as the magpie or the smile of the Venus figure.

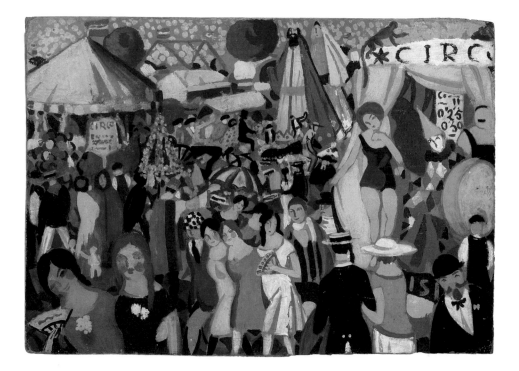

[C3]
THE FAIR OF THE HOLY CROSS AT FIGUERES. c. 1922.
Temper on cardboard (52 x 75 cm)
Room 5 Fishmongers' Room

A work of great chromatism that portrays the fairs of Figueres, which are held at the beginning of May, around the 3rd, the festival of the Holy Cross. We should highlight the gathering of people befitting the days of a fair: the bullfighter returning to the square in a carriage; the footballer, still in his coat, who is going to or coming from the game; the circus characters, the easels, the giants, in the background, and the diverse mass of people. In the lower right-hand corner the face of a character appears who, according to Dalí, came to the fairs from the neighbouring country. In *A diary: 1919-1920 My impressions and intimate memories*, Dalí gives beautiful descriptions of the fair days: "It has an exquisitely Hellenic flavour about it". He writes of "illuminated and lively" days, and about the atmosphere, so well reflected in this painting.

[C4]
THE FIRST DAYS OF SPRING, c. 1922-23.
Chinese ink and wash on paper (20.80 x 15 cm)
Room 5 Fishmongers' Room

In 1922 Dalí was staying in the Madrid Students' Residence, something that would have an important bearing on his personal and artistic life. There he made friends with Federico García Lorca, Luis Buñuel and Pepín Bello. In this period he produced works featuring the scenes of Madrid nightlife in which the influence of the painter Rafael Barradas is reflected. This work, however, is a lyrical evocation of daily life in Figueres, his birthplace, full of feelings and sensations. The memory is focused on the character in the centre, himself, and the different scenes that surround him: the lovers on the public bench, the woman hanging the clothes, the cock crowing, the clock marking the inexorable march of time, the students, the woman making lace, the children playing in the courtyard, or the plane, the moon and the birds.

[C5]
PORT ALGUER, c. 1923.
Oil on canvas (100.50 x 100.50 cm)
Room 4 Treasure Room

A painting produced in the open air, it is a structuralist vision of Cadaqués. The sea and its reflections are formed by a series of impressionist brushstrokes. The two feminine figures are two women of Cadaqués with the typical green water jug on their heads. This mixture of styles shows us the work of an artist in the middle of the process of experimentation and the search for creative resources. *Purist still life*, from 1924, is from the same period, and shows the influence of Juan Gris. Both are usually exhibited in the Treasure Room, facing each other, so that we can see that both are structured around the rose window of the church of Cadaqués and the cubic forms of the whole, although only in the second does Dalí enter into formal investigations of purism.

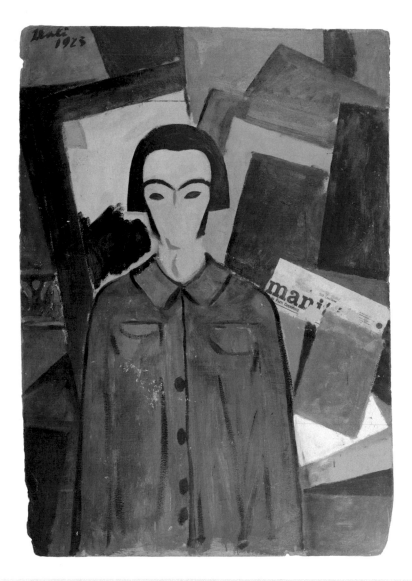

[C6]
SELF-PORTRAIT WITH *L'HUMANITÉ* , 1923.
Temper, oil and collage on cardboard (105 x 75 cm)
Room 5 Fishmongers' Room

Dalí painted himself dressed as a worker and wanted to record a rebellious and provocative attitude, with a cutting from the communist newspaper *L'Humanité*, which seems to certify his stated admiration for the idea of revolution and places him in a specific historical and ideological moment in time. The oil painting dates from 1923, though the collage of the newspaper within the cardboard is from the 24th of July 1928. The influence of Rafael Barradas is present, whose work he saw in the Ateneillo de L'Hospitalet, both in terms of the geometric structures of the paintings in the background of the workshop and in the newspaper itself or the schematic definition of the traits of the self-portrait. In this period, Dalí often painted self-portraits and summarised himself in his works with some clearly defined features: eyebrows, eyes and sideburns.

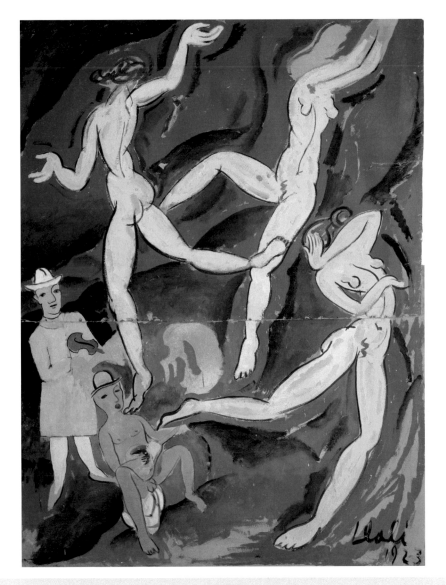

[C7]
SATIRICAL COMPOSITION, 1923.
Oil on cardboard (138 x 105 cm)
Room 5 Fishmongers' Room

Composition clearly inspired by Matisse that fully coincides with the French artist's *The Dance*. Moreover, it is worth pointing out the presence of rather satirical characters, in the lower left hand corner of the oil painting, related to the popular aesthetic of ceramics. Dalí reminds us of popular Russian iconography, especially that presented by Marc Chagall, in a work not exempt of both irony and satire given the double meaning of one of the instruments being played by the characters.

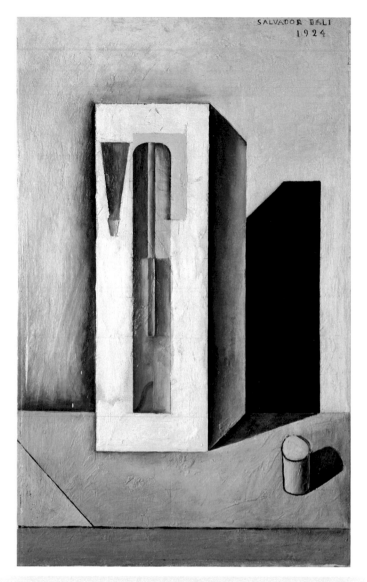

[C8]
SIPHON AND SMALL BOTTLE OF RUM (CUBIST PAINTING), 1924.
Oil on canvas (80.50 x 50 cm)
Room 4 Treasure Room

This oil painting, half way between the cubist tendencies of the time and the works of the Italian metaphysicists that he had seen in the magazine *Valori Plastici*, was shown in two important exhibitions in 1925: the First Exhibition of the Society of Iberian Artists, in the Exhibition hall of the Retiro in Madrid and in his first one-man exhibition in the Dalmau Galleries in Barcelona. That same year he wrote to Federico García Lorca: "I am working on some tests with the aim of constructing the atmosphere, or rather, the construction of the void...I believe that the plasticity of empty spaces is of great interest, but which no-one has been concerned with, since this plasticity almost always results in that of solid matter".

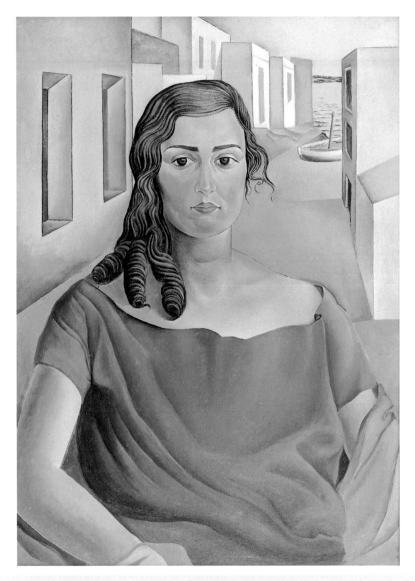

[C9]
PORTRAIT OF MY SISTER, 1925.
Oil on canvas (92 x 65 cm)
Room 5 Fishmongers' Room

Oil painting also on show in his first one-man exhibition in the Dalmau Galleries in Barcelona, from the 14th to 27th of November 1925. It is a portrait of Anna Maria, the artist's sister, who was his model throughout the twenties. This oil painting exemplifies the futurist influence that had such a big impact on Dalí at the time, particularly the work of Carrà, but also others such as De Chirico or Boccioni. The landscape surrounding the person, Cadaqués, is more symbolic than real and once again corresponds to the influence of the aesthetics that appeared in the magazine *Valori Plastici*.

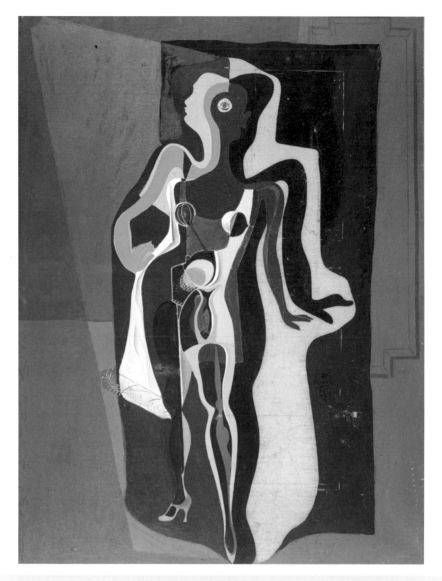

[C10]
BARCELONA MANNEQUIN, 1926.
Oil on canvas (198 x 148 cm)
Room 5 Fishmongers' Room

Work present in the Exhibition of Catalan pictorial Modernism confronted by a selection of works by foreign avant-garde artists, held between the 16th of October and 6th of November 1926 in the Dalmau galleries in Barcelona. Sebastià Gasch wrote in the preface of show: "Modern painting is no more than the same painting that all the grand periods of art history have known; the same painting, but stripped of all the extra-artistic concerns that disfigured it on occasions and which prostituted it in the majority of cases". We can see the triple silhouette of the head, with the suggestive and descriptive shadows. The mannequin is made up of different forms and symbolic elements such as the eye, the half-moon, the fish with its sexual symbolism or the garter.

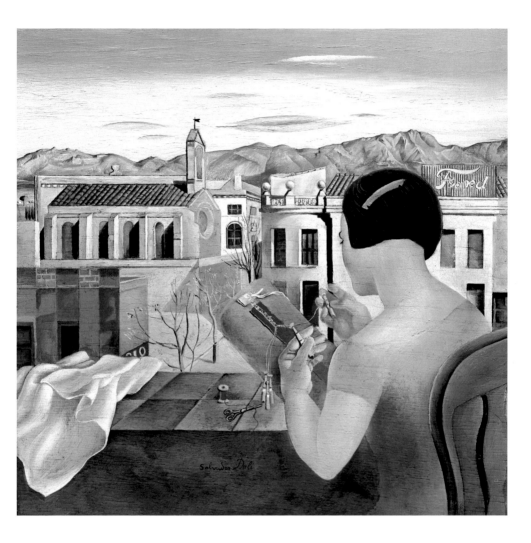

[C11]
THE GIRL OF FIGUERES, 1926.
Oil on panel (20.80 x 21.50 cm)
Room 4 Treasure Room

An oil painting that formed part of his second one-man exhibition in the Dalmau Galleries in Barcelona, held from the 31st of December 1926 to the 14th of January 1927, which shows his first trip to Paris in April 1926, when he visited Picasso's studio, who he considered a Master painter. It is a disturbing work due to the realist precision of the landscape compared to the imagined character, which we associate with a feminine stereotype of the fashion and publicity of the time. With this in mind, the advert for the Ford motor company stands out. In the painter's final period in Figueres, in Torre Galatea, he had repeatedly insisted on his wish to recover this oil painting to exhibit it in his Theatre-Museum. He was finally able to acquire it and it is generally on show in the Treasure Room.

[C12]
STILL LIFE BY MAUVE MOONLIGHT, 1926.
Oil on canvas (148 x 199 cm)
Room 4 Treasure Room

Shown at Dalí's second one-man exhibition in the Dalmau Galleries in Barcelona from the 31st of December to the 14th of January 1927. Another work with the clear influence of Picasso and which Dalí himself thought of as a foreshadowing of his famous soft clocks. Compared to the previous oil painting, *The Girl of Figueres*, it eloquently shows the step from realism with imaginative contributions towards greater freedom, where there is evidence of both Picasso's influence and that of the literary-plastic art imagery of Federico García Lorca. The idea of the incorporeal head is influenced by Picasso's *Study with plaster head* of 1925.

[C13]
FIGURES LYING ON THE SAND, 1926.
Oil on panel (20.70 x 27.30 cm)
Room 4 Treasure Room

Shown at Dalí's second one-man exhibition in the Dalmau Galleries in Barcelona from the 31st of December to the 14th of January 1927. This work must have been inspired by Dalí's visit to Picasso's Paris studio, the impact the visit had on him along with his expulsion that same year from the Fine Art School of San Fernando in Madrid, representing a change in Dalinian work and the beginning of innovative aesthetic paths. It is a structured, geometric, very carefully worked piece, with clear influences from Juan Gris and Georges Seurat. The figures are solid, corporeal, vegetative and totally integrated into the rocks. Dalí qualified these squatting feminine figures disdainfully as "wooden blocks", wanting to define them as static elements of cork scattered over the earth.

[C14]
INAUGURAL GOOSE FLESH, 1928.
Oil on cardboard (76 x 63.20 cm)
Room 4 Treasure Room

This work, advance notice of Dalí's great pictorial production in the thirties, is the one he showed to André Breton and the surrealist group. There is a certain resonance of Tanguy, both in the way of constructing the space and in the soft, white shapes that float on the oil painting. They are corpuscular forms in line with a hypnagogic vision, which combines the arithmetic rigidity of a numerical series, confronting, in this way, the dominant romanticism of his origins with the initial submission to a strict set of rules he learned in the magazine *L'Esprit Nouveau* by Ozenfant and Jeanneret (Le Corbusier). Dalí wanted to give a value to and number something indefinite.

[C15]
ROTTING BIRD, c. 1928.
Mixed media on cardboard (35 x 57 cm)
Room 5 Fishmongers' Room

A clear example of Dalí's first explorations into the surrealist world, with coincidences with Joan Miró. It is worth pointing out the extension that this aesthetic had in the creations of the *Dau al Set* group, in the form of monsters, double images and transformations. It represents Dalí's total and free experimentation in the world of the subconscious, with the use of elements that anticipate, in the art world, the collage made with sand and other media. In this sense, Sebastià Gasch stated in *L' Amic de les Arts* [Friend of the Arts]: "A totally removed procedure, almost in the antipodes of that used by painters until now. A cleanly ANTI-PICTORIAL procedure. So now we are before the famous art assassin". Snails, fossils, objects with phallic meanings, all form part of this decaying universe of birds, heavenly bodies and phantasmagorias that rise up from the earth, with some very well marked footprints in the foreground.

[C16]
PARANOIAC METAMORPHOSIS OF GALA'S FACE, 1932.
Pencil and ink on paper (29 x 21 cm)
Room 20 Optical illusions Room

The artist presented this work in the exhibition titled "Salvador Dalí", held in the Pierre Colle Gallery in Paris, from the 26th of May to the 17th of June 1932. The introduction to the catalogue is a poem by Paul Éluard called "Salvador Dalí". It is the first detailed portrait that he did of Gala, who he had met in 1929. The painter, in line with his paranoiac-critical method, discovers different associative relationships in the face of Gala that project onto the right-hand side of the work: bread, the cypress, the inkpots, the soft clock, the shoe, the spoon, the soft forms, etc. These objects make up a kind of iconographic constellation which would be used in the series of engravings to illustrate *Les chants de Maldoror* by the Count of Lautréamont in 1934.

[C17]
PORTRAIT OF GALA WITH TWO LAMB CHOPS BALANCED
ON HER SHOULDER, 1933. Oil on panel (6.80 x 8.80 cm)
Room 14 Masterpiece Room

In reference to this fantastic and detailed portrait, Dalí explains to us in *Secret Life*: "As soon as we had got settled in Portlligat, I painted a portrait of Gala with a pair of raw chops poised on her shoulder. The meaning of this, as I later learned, was that instead of eating *her*, I had decided to eat a pair of raw chops instead. The chops were, in effect, the expiatory victims of abortive sacrifice —like Abraham's ram, and William Tell's apple—. (...) My edible, intestinal and digestive representations at this period assumed an increasingly insistent character. I wanted to eat everything, and I planned the building of a large table made entirely of hard-boiled egg so that it could be eaten".

[C18]
FIGURE AND DRAPERY IN A LANDSCAPE, 1934.
Oil on canvas (55.70 x 46 cm)
Room 20 Optical illusions Room

The origin of the ghostly sheet seems to have been suggested by a photograph that Dalí took in Portlligat in 1932, in which you can see Gala and René Crevel half hidden behind a sheet. Totally or partially clothed figures appear in some works in this period. The volumetric anxiety is portrayed in the cloud in the centre of the canvas, which contrasts with the deepness of the landscape and the solitary nature of the character. In 1934, Dalí published the article "Les nouvelles couleurs du sex-appeal spectral" in issue number 5 of the magazine *Minotaure*, in which he stated: "the phantom materialises in the 'semblance of volume'. The semblance of the volume is wrapping. The wrapping hides, protects, transfigures, incites, tempts, and provides a false vision of the volume. It makes us ambivalent to the volume and makes it worthy of suspicion".

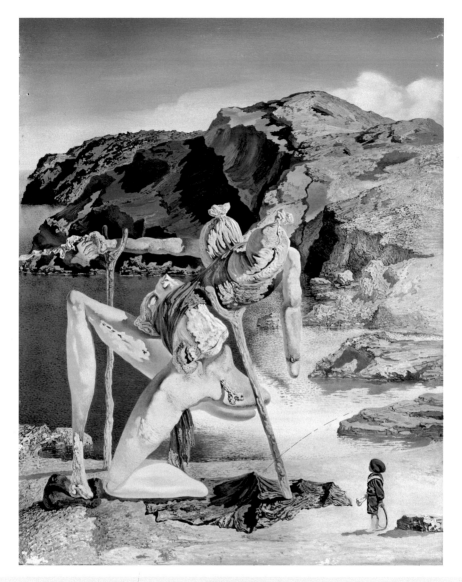

[C19]
THE SPECTRE OF SEX-APPEAL, 1934.
Oil on panel (17.90 x 13.90 cm)
Room 4 Treasure Room

Dalí exhibited this oil painting in 1934, in the Jacques Bonjean Gallery in Paris, and later in the Julien Levy Gallery in New York, and introduces this fragment of text in both catalogues: "Instant photo in colours at hand" subconscious, surrealist, extravagant, paranoiac, hypnagogic, extra-pictorial, phenomenal, superabundant, super-fine images, etc... of concrete irrationality...". On the right-hand side, we see Dalí as a child, dressed as a sailor, looking at an enormous monster, soft and hard at the same time, which for the artist symbolised sexuality, all of it framed by a hyper-realist Cap de Creus. This work is the concrete definition of a difficult-to-perceive feeling: the monster of sexuality, as precise as the landscape of his childhood, the rocks of Cap de Creus. We should emphasise the imposing presence of the crutches, to Dalí a symbol of death and resurrection.

[C20]
SINGULARITIES, c. 1935.
Oil and collage on board (40.50 x 50 cm)
Room 4 Treasure Room

Work of great symbolic and iconographic impact, with multiple associations and disturbing components in the midst of a night-time setting. Extremely important elements of Dalinian imagery appear such as the soft clock, the rocks of Cap de Creus —Cadaqués—, the soft forms, the figures with open drawers on their fronts, the loaf of bread or the piano. The anthropomorphism of the hairy curtain should also be noted. In this work Dalí applies his theory according to which the accumulation of unconnected ideas finally converts them into harmony. The central character seems to come from a stage performance or a ballet, with a powerful geological element to their left and, on the right, a disturbing cubic building and an anthropomorphic chair.

[C21]
SURREALIST COMPOSITION WITH INVISIBLE FIGURES, c. 1936.
Oil on cardboard (60.90 x 45.80 cm)
Room 20 Optical illusions Room

This work, heavily charged with meaning, was produced in two stages, with a space of ten years between them. Dalí began the oil painting in 1926 and provides us with a vision of the magnificent scenery he had in front of his house, in Llaner in Cadaqués: the sea, the bay, with the east coast as the horizon and dividing line of the painting separating two quite distinct parts. When he completely redid the lower half of the work, Dalí replaced the rocky landscape and the figure of a bather with a whitish strip in the way of a stage, where he places, for sure, his absence, his ego expressed by a polychrome pedestal and ruby heart, as he had already shown us in *The Invisible Man* or in *The First days of Spring*, both from 1929. It is also worth stressing the absent figures, both in the chair and the bed, and the presence of the ants.

169

[C22]
AVERAGE PAGAN LANDSCAPE, 1937.
Oil on canvas (38.40 x 46.40 cm)
Room 20 Optical illusions Room

Oil painting painted during a stay in Italy, with the influence and presence of Freud, anthropomorphised in the rocks. Just as Dalí showed later, in 1958, in his Anti-Matter Manifesto: "During the surrealist period I have wanted to create the iconography of the inner world, the world of marvels, of my father Freud; I have achieved it". In this work Dalí represents the transformations of the rocks, some with anthropomorphisms. On the left, in the foreground, there is a farmer hermetically sealed in his own thoughts. Dalí paints the concept of idea emerging from the farmer's head. In the background are some figures, among them a dandy that is almost certainly a self-portrait. As often occurs in his imaginary landscapes, a cloud that emerges in a volumetric form laden with mystery overlooks the scene.

[C23]

[C23]
THE IMAGE DISAPPEARS, 1938.
Oil on canvas (56.30 x 50.50 cm)
Room 5 Fishmongers' Room

Dalí exhibited it in the Salvador Dalí show held in the Julien Levy Gallery in New York in 1939. It is one of the most famous double images developed from his paranoiac-critical method: in the oil painting, at first sight we can see a female figure who is reading a letter in a room, with a map in the background, that recalls almost literally the famous Vermeer work, The Reader and, at the same time, with a simple acceptance by our perception, represents the portrait of Velasquez. With this double solution, in one single painting we have two of the most outstanding figures of the art world according to Dalí, Vermeer de Delft and Velasquez.

[C24]
TWO PIECES OF BREAD EXPRESSING THE SENTIMENT OF LOVE, 1940.
Oil on canvas (81.30 x 100.30 cm)
Sala 19 Loggia: optical games and stereoscopes

Dalí painted this oil painting in spring 1940 in Arcachon, close to Bordeaux, and exhibited it in the Julien Levy Gallery in New York. In the preface of the catalogue, *The latest scandal of Salvador Dalí*, he says: "...during these chaotic times of confusion, of doubt and of growing demoralization (...) Dalí himself, I repeat, finds the unique attitude towards his destiny: TO BECOME CLASSIC! As if he has said to himself: Now or never". The presence in the painting of an enigmatic and hyper-realist chess pawn is a homage to the artist and friend Marcel Duchamp, who at that time was staying as a guest with Dalí and Gala and would often play chess with her in the afternoon. Dalí had composed a model for a still life in which, by chance, a chess pawn had fallen that the artist wanted to keep in the composition. The crusts of bread recall the still life paintings, both symbolic and realist at the same time, of Sánchez Cotán or Zurbarán.

[C25]
CENTAUR, 1940.
Pencil and gouache on paper (77 x 56 cm)
Room 16 "Poetry of America" Room

Dalí enables us to appreciate, in some of his illustrations with the intention of being the final work, as if we were before a Leonardo da Vinci, his command of this artistic technique. Dalí placed special emphasis on the winged boots in the form of jewels of the character, reminding us of his jewellery design. If his drawing has a Leonardo-like expression, the details recall Benvenuto Cellini. This illustration was used as the model for the engraving of the glass cup titled *The Dream of Nautilus*. The central character is, at the same time, a vessel driven by the wind in full sail. The two large spheres, legs in movement, attract our attention. The two centaurs give the group both gesticulating characters. On the left, a feminine character leaning on a pole has the attitude of Angelica or perhaps Saint Sebastian.

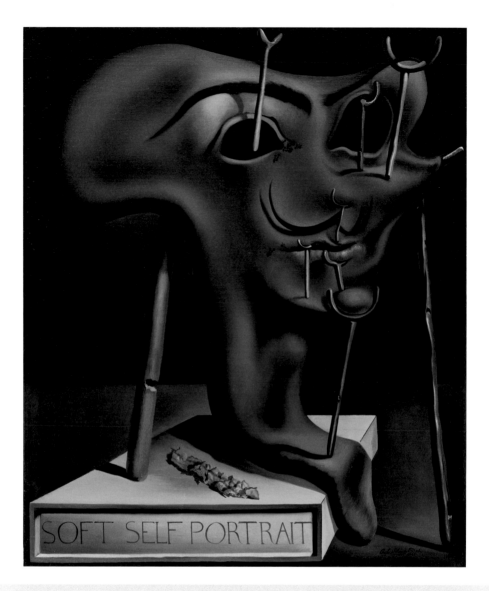

SOFT SELF PORTRAIT WITH GRILLED BACON, 1941.
Oil on canvas (61 x 51 cm)
Room 5 Fishmongers' Room

A spectre full of irony, where an amorphous, soft face appears, supported by crutches, which Dalí considered his self-portrait, with a pedestal that bears the inscription of the title of the work and, above, a slice of fried bacon, a symbol of organic matter and of the everyday nature of his breakfasts in New York's Saint Regis Hotel. Dalí always remembered the piece of flayed skin with which Michelangelo represented himself in the Sistine chapel in the Vatican and argued the most consistent thing of our representation is not the spirit or the vitality, but the skin.

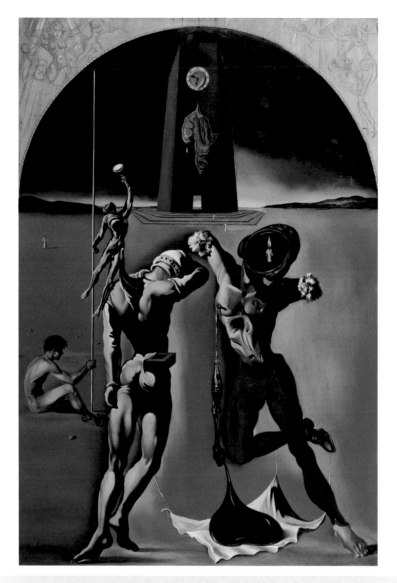

[C27]
POETRY OF AMERICA, 1943.
Renamed THE COSMIC ATHLETES, Oil on canvas (116 x 79 cm)
Room 16 "Poetry of America" Room

Dalí painted this oil painting in the United States, in Monterrey, California, in 1943. The landscape is a mixture of the Empurdá plain and Cap de Creus and of the vast American deserts. The skin shaped as Africa appears in the background, on the tower of time, with the clock marking the time and the athletes —American football players— with the vertical symbolism of the Coca-Cola bottle between them, and the black telephone, encrusted into the bottle, from which comes a huge black stain that falls onto a white cloth that is attached to the athletes. The black stain has been the object of different interpretations, one of which ponders with the idea that it is a representation of the American racial problem. This work, produced during the American period, is advance notice of the new cultural attitudes in the 20th century, especially that of pop art.

[C28]
STUDY FOR "GALARINA", 1943.
Pencil on paper (72.30 x 53.70 cm)
Room 15 "Palace of the Wind"

Dalí the illustrator, admirer of Ingres —who he copies a quotation of in the same drawing: "Drawing is the integrity of art"— and of the grand masters of the Renaissance, such as Michelangelo, Raphael or Leonardo. The artists also quotes himself: " Every line of the drawing must be geodesy" and places himself within this tradition. It is worth noting the jewellery that Gala is wearing, represented with sublime meticulousness and beauty. It is a drawing of great precision: Dalí has a total command of this art and makes us become involved in it.

PROJECT FOR THE BACKDROP OF "MAD TRISTAN" (ACT II), 1944.
Oil on canvas (60 x 96 cm)
Room 5 Fishmongers' Room

A work, and it could not have been any other way, of Wagnerian, grandiloquent representation. Dalí, multifaceted artist, produced diverse stage sets for the theatre and ballet. He wrote the score and designed the backdrop, decorations and costumes for this ballet, with choreography by Léonide Massine, which was performed in New York on the 15th of December 1944. Dalí's argument was inspired by musical subjects such as Tristan and Isolde, by Wagner. It is the "first paranoiac ballet based on the eternal myth of love until death". The central part of the work makes a clear reference to *The Island of the Dead*, by Böcklin, with two rocky forms, relating to its landscape; in the sky, the two clouds refer to the figures of Millet's *Angelus*.

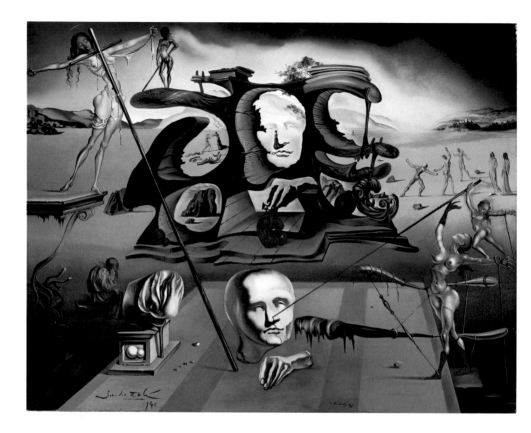

[C30]
NAPOLEON'S NOSE, TRANSFORMED INTO A PREGNANT WOMAN, STROLLING HIS SHADOW WITH MELANCHOLIA AMONGST ORIGINAL RUINS, 1945. Oil on canvas (51 x 65.50 cm)
Room 4 Treasure Room

Dalí, in the catalogue for the exhibition held in the Bignou Gallery in New York, that ran from the 20th of November to the 29th of December 1945, stated that he painted this work in three weeks, working two hours a day, and added that the title explained the painting completely. It is a meticulously painted piece, absolutely structured, with perfect geometries. The painting is exuberant, full of nuances and iconographic references: Napoleon, architecture, the double image, crutches, the Empordá region... and totally theatrical. It is a surrealist work in the Dalinian way, with wide and desolate spaces and almost academic Freudian symbols.

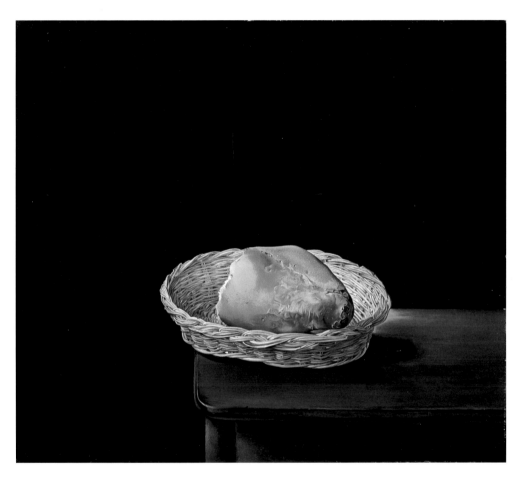

[C31]
THE BASKET OF BREAD, 1945.
Oil on canvas (34.70 x 43.50 cm)
Room 4 Treasure Room

Dalí exhibited it in the "Recent Paintings by Salvador Dalí" show, held in the Bignou Gallery in New York, from the 20th of November to the 29th of December 1945, and in the catalogue he wrote about it: "I painted this work for two consecutive months, four hours a day. During this period the most surprising and sensational episodes occurred in contemporary history. This work was finished one day before the end of the war. Bread has always been one of the oldest fetishist and obsessive subject matters of my work, to which I have remained most faithful. Nineteen years ago I painted the same subject. If you make a detailed comparison between the two works, you can study the whole history of painting, from the lineal charm of primitivism through to the stereoscopic hyper-aestheticism. This typically realist work is the one that has most satisfied my imagination. Here we have a painting about which nothing can be said: the total enigma!"

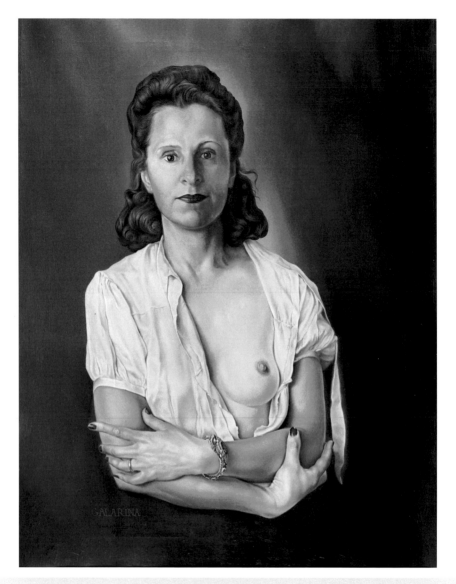

[C32]
GALARINA, 1945.
Oil on canvas (64.10 x 50.20 cm)
Room 4 Treasure Room

In the catalogue for the exhibition in the Bignou Gallery in New York, held from the 20th of November to the 29th of December 1945, Dalí stated: "Begun in 1944, this work was completed in six months, working three hours a day. I called it *Galarina* because Gala is to me what La Fornarina was to Raphael. And, without any pre-meditation, here again we have...the bread! A rigorous and keen-eyed analysis will show that Gala's crossed arms are like the interwoven wicker of the breadbasket, and her breast, the crust of bread. I have already pain-ted Gala with two lamb chops on her shoulder, as an expression of my subconscious desire to devour her. That was the age of the imagination's raw meat. Today, now that Gala has risen in the heraldic hierarchy of my nobility, she has become my basket of bread".

[C33]
PORTRAIT OF PABLO PICASSO IN THE XXI CENTURY (ONE OF A SERIES OF PORTRAITS OF GENIUSES:
HOMER, DALÍ, FREUD, CHRISTOPHER COLUMBUS, WILLIAM TELL, ETC), 1947. Oil on canvas (65.50 x 56 cm)
Room 5 Fishmongers' Room

Allegorical portrait of Picasso, painted during Dalí's American stage and exhibited in the Bignou gallery in New York, from the 25th of November 1947 to the 31st of January 1948. Dalí wanted it to form part of the permanent collection in the Dalí Theatre-Museum of Figueres and decided to place it in the Fishmongers' Room facing his *Soft Self-portrait with Grilled Bacon*, of 1941. He gave the oil painting a long name, qualified Picasso as a genius —in the work *Moi aussi j'ai connu l'Empereur* he saw him as an emperor and would present him crowned with a laurel wreath— and placed him in the XXI century, both in the title and on the canvas, where the corresponding Roman numerals appear. The carnation, the goat's horns or the mandolin refer to values such as intellectualism, the exaltation of ugliness or the sentimentalism present in the work of the Malaga artist, for whom he felt great admiration.

181

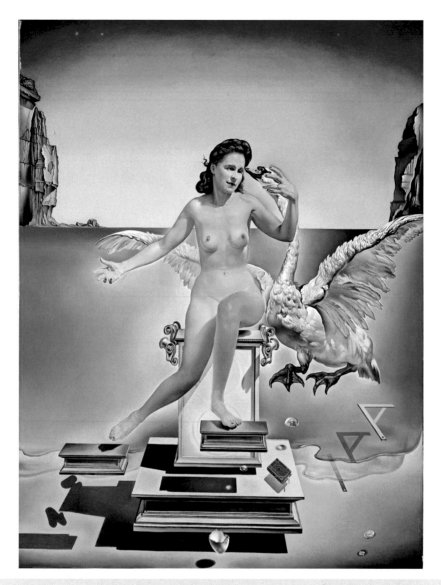

[C34]
LEDA ATOMICA, 1949.
Oil on canvas (61 x 46 cm)
Room 4 Treasure Room

In the catalogue of the exhibition in the Bignou Gallery in New York, held from the 25th of November 1947 until the 31st of January 1948, Dalí announced that he was now 44 years old and had finally decided to start his first master works. He added that he was showing this work while it was still in progress, thus enabling those interested in his technique to study the development of his work coinciding with the publication of his book *50 Secrets of Magic Craftsmanship*. We are once again before a work of mythological echoes, which interested Dalí so much. Produced according to Fra Luca Paccioli's "Divine Proportion", there are also references calculated by the mathematician Matila Ghyka. In contrast to what his contemporaries believed, that mathematics "distracted" from the artistic discourse, Dalí thought that any work of art with foundation had to be based on the composition, on the calculus. Of note here is that all the elements are shown weightless, suspended in air, floating.

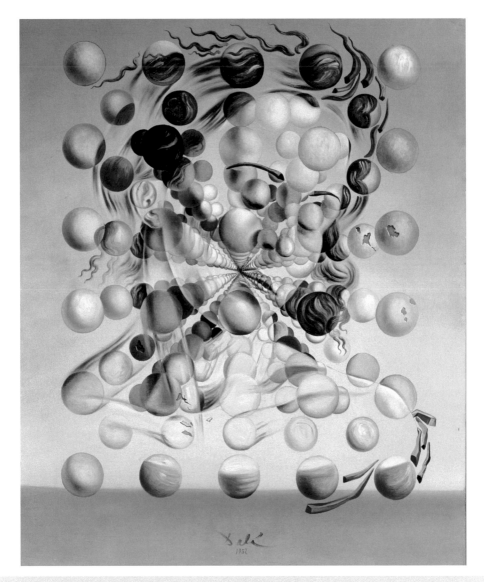

[C35]
GALATEA OF THE SPHERES, 1952.
Oil on canvas (65 x 54 cm)
Room 15 "Palace of the Wind"

One of the most representative works from the nuclear mysticism period. It is the outcome of a Dalí impassioned by science and for the theories of the disintegration of the atom. Gala's face is made up from a discontinuous, fragmented setting, densely populated by spheres, which on the axis of the canvas takes on a prodigious three-dimensional vision and perspective. As Dalí clarified in his *Anti-Matter Manifesto*: "Today, the exterior world —the physical one— has gone beyond the psychological one. My father, today, is Doctor Heisenberg". It is one of the most eloquent acts of homage to Gala's face that Dalí produced, and he wanted it to be seen in the Palace of Winds in his Theatre-Museum, on an easel that had belonged to Meissonier, a painter of whom there are two works in the museum that formed part of Dalí's private collection.

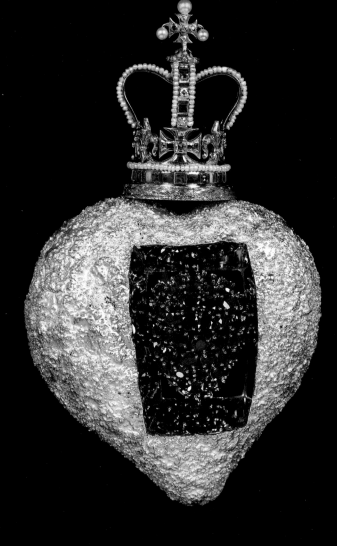

[C36]
THE ROYAL HEART, 1953.
(24.50 x 12.80 x 9.50 cm)
Room 23 Jewels

Jewellery piece that once belonged to the American Owen Cheatham collection, acquired in 1999 by the Gala-Salvador Dalí Foundation, of which it is the most outstanding piece. For Dalí, jewellery was not a simple means of expression, but was the embodiment and wanted it to capture his art, his way of thinking and his artistic evolution. In relation to this piece he wrote: "The rubies that beat represent the queen, whose heart beats constantly for her people. The pure gold heart symbolises the people who shelter and protect their sovereign".

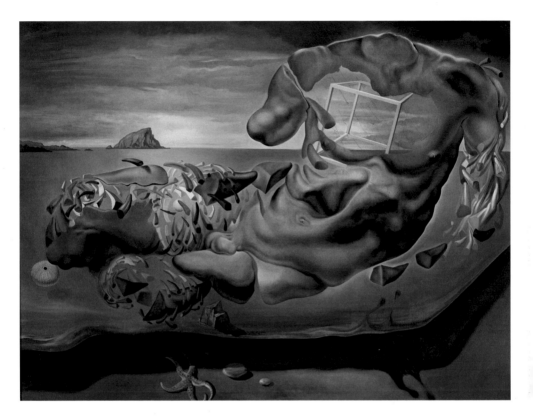

[C37]
RHINOCEROTIC FIGURE OF "ILLISUS" OF PHIDIAS, 1954.
Oil on canvas (101.50 x 131 cm)
Room 5 Fishmongers' Room

The central motif of the oil painting is one of the impressive marble sculptures that Phidias produced for the west pediment of the Parthenon of the Acropolis in Athens. Dalí began this work in summer 1953, in his studio in Portlligat. The scenery of Cadaqués appears again, with the characteristic outcrop, *Es Cucurucuc*, on the horizon. Regarding this canvas, Dalí wrote in *Diary of a Genius*: "1953 – AUGUST. The 17th. Through excessive caution, I put so little paint on the right thigh that, seeking to add some colour, I smudge my painting (...) The most re-secret secret is that I, the most famous painter in the world, don't know how a painting is done. Nevertheless I am very close to knowing it, and all of a sudden I shall paint a picture that will be like those of antiquity. I work on Phidias' testicles to give me courage. Oh, if only I were not afraid of painting! But, in the end, I want each brush stroke to achieve the absolute and give the perfect image of the painting's testicles, testicles that are not mine".

185

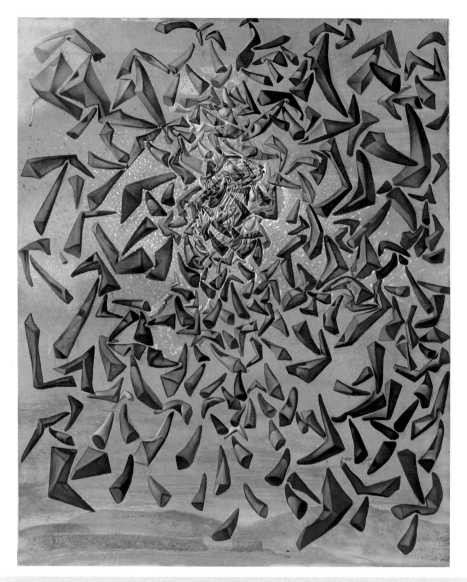

[C38]
ASCENSIONIST SAINT CECILIA, 1955.
Oil on canvas (81.70 x 66.70 cm)
Room 20 Optical Illusions Room

Painting representative of his atomic or nuclear mysticism period. It is a composition with a great spatial expansion, with the volumetric spirals creating a three-dimensional effect, also reflected in other canvases such as *Galatea of the Spheres, Portrait of Gala with Rhinocerotic Symptoms*, or *Rhinocerotic Figure of Illisus of Phidias*. A concentric work in which the chromatism is focused on the image of the saint, which explodes into golden particles that accompany the shapes based on the rhinoceros horn (an ever-present symbol in Dalí's atomic stage), which seem to give us advance notice of the alarmist writings of the eighties.

[C39]
GALA FROM BEHIND LOOKING IN AN INVISIBLE MIRROR. 1960.
Oil on canvas (41 x 31.30 cm)
Room 4 Treasure Room

Gala's torso is here supported in the triangle formed by her arm and right leg. The structure of the sheeting, also geometrical, should also be studied, to which Dalí affords as much, if not more, importance than the central subject matter of the body. We should remember that during his studies in the Fine Art School of San Fernando in Madrid, he showed his admiration for one of his teachers, the draping teacher, the well-known painter Julio Romero de Torres. This work is a new version of the 1945 oil painting *My Wife, Nude, Contemplanting Her Own Flesh Becoming Stairs, Three Vertebrae of a Column, Sky and Architecture*.

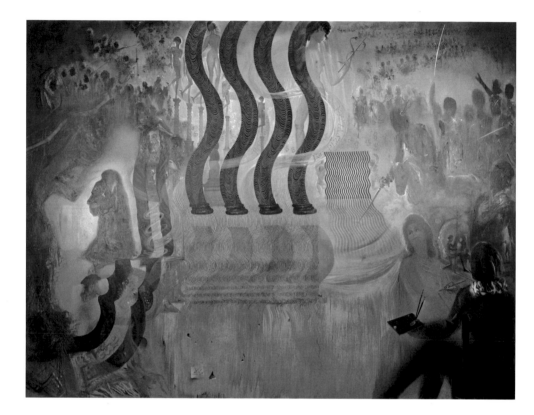

APOTHEOSIS OF THE DOLLAR, 1965.
Oil on canvas (300 x 400 cm)
Room 23 Jewels

In this canvas, just as in his Theatre-Museum, Dalí reflects all the tendencies, myths and obsessions that accompanied him throughout his life. Let us recall some of them: Duchamp on the left-hand side dressed as Louis XIV with Watteau's lute player over his head; José Nieto, the Queen's quartermaster of *Las Meninas*, who appears as many as three times. Beside Duchamp-Louis XIV, the profile of Hermes by Praxiteles, who has the figure of Goethe in the shadow of its nose, and in the corner of its mouth, the portrait of Vermeer de Delft. On the right-hand side, Dalí paints himself, like Velásquez, in the act of painting Gala, at whose side appears the double image of Dante's Beatriz, who is, at the same time, a kneeling Quixote. Above, we can see Napoleon's defeated armies, while in the top left-hand corner we can make out the soldiers of the Battle of Tetuán in full force (reminiscences of Meissonier in some and of Fortuny in others).

[C41]
CHALICE OF LIFE, 1965.
(41 x 24 x 21.5 cm)
Room 23 Jewels

Igor Cassini, in the March 1961 issue of *Town & Country*, explained that Dalí and Alemany & Company were creating a new art form: "It is a work of art of electronic jewellery that represents the chalice of saint Theresa of Ávila (...) When the piece is activated, the gilded leaves that surround the chalice will open and turn into butterflies decorated with precious stones (...) The jewel, around seventy-five centimetres high, will represent the legend of saint Theresa by means of the dead leaves turning into living butterflies, and will become an exhibition piece". According to Dalí, as he stated in the *New York Telegram and Sun* in 1964: "Mankind lives surrounded by putrefaction. Like a worm, he drags himself through life carrying death. But for the grace of a divine metamorphosis, as in the metamorphosis of the butterfly, he is transformed into a spiritual light".

[C42]
"CUANT CAU, CAU", [WHEN IT FALLS, IT FALLS], 1972-73.
Oil on canvas (195 x 297 cm)
Room 22 "When it falls, it falls..." Room

A Dutch-style still life, acquired by the artist in Paris and "dalinised". Dalí said: "Instead of being a collage it is an oil painting transformed by me". The painter turned it into an allegory and homage to his friend, the Catalan philosopher, Francesc Pujols. In the background of the canvas we can make out distinct transformations carried out by Dalí, who uses the original painting to create the duality. Standing out from a colourful collage is a hook that comes out from one of the characters. The oil painting has a phrase of Pujols inscribed in it: *"cuant cau, cau"*, which gives the piece its title and which is the conclusion of an extensive and complex philosophical text that greatly interested him.

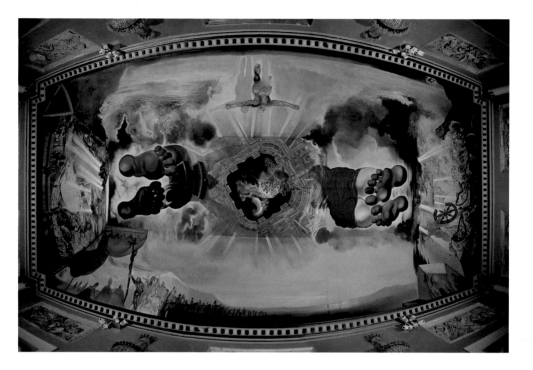

[C43]
CENTRE PANEL OF THE CEILING OF THE PALACE OF THE WIND, 1972-73.
Oil on canvas (114 x 570 cm)
Room 15 "Palace of the Wind"

Painting produced in the studio in Portlligat, although he completed it raised on enormous scaffolding and placed in his Theatre-Museum. It is a work based on the poem by Joan Maragall, "El Palau del Vent" (The Palace of Wind) that refers to the Empordá region and the Tramuntana (the northern wind). In the centre he represents himself alongside Gala, in a forced perspective so that it creates an allegorical argument of the different passages of his life. This work has something of an idyllic stroll through the dreams of life about it. At the end, it once again shows Gala and himself, contemplating the ship of destiny which is just about to set sail. We can highlight some sections of the journey: the shower of gold that falls onto the spectator as coins (Dalí used to say that one of them was real); the reference to the Lulian wheels; the elephants with insect limbs; the sketched silhouettes of the prince and princess (the current King and Queen of Spain). In the corner one can also see the silhouette of the photographer and good friend of Dalí, Melitó Casals, "Meli".

[C44]
DALÍ FROM THE BACK PAINTING GALA FROM THE BACK ETERNALIZED BY SIX VIRTUAL
CORNEAS PROVISIONALLY REFLECTED BY SIX REAL MIRRORS, 1972-73. Oil on canvas (60.50 x 60.50 cm)
Room 14 Masterpiece Room

Stereoscopic work, an example of the experiments that Dalí undertook in the seventies. Through the stereoscope,
the artist wanted to reach the third dimension and achieve the effect of depth. As in *Las Meninas*, the painter also
appears in his own creation. In 1975 he wrote the following poem that illustrates this canvas very well:

*In order to see myself behind my shoulders / Painting your much-loved ones / I look into one of your mirrors, /
And into another identical one, / Our effigies reflected. / I third mirror I need, / So that between my four pupils, /
I have you fixed. / Making true love / The myth fixing me with yours / Eight pupils in one single look. / Thus you have
me as slave and master, / I deserve the highest of all decorations. / I am a nightingale enclosed in a cage, / Made up
of ten pupils converging on my brush / Three mirrors carved in the form of a diamond / In order to see, lover and
maiden, / The single mirror of our soul.*

[C45]

HOLOS! HOLOS! VELAZQUEZ! GABOR!, c. 1972-73
Hologram (42 x 57 cm)
Room 15 "Palace of the Wind"

Dalí presented this hologram in the exhibition titled *The 3rd Dimension: The 1st World Exposition of Holograms Conceived by Dalí* in the Knoedler Gallery in New York, from the 7th of April to the 13th of May 1972. At the presentation, Dalí stated: "All artists have been concerned with three dimensional reality since the time of Velasquez, and in modern times, the analytic cubism of Picasso tried again to capture the three dimensions of Velasquez. Now with the genius of Gabor, the possibility of a new Renaissance in art has been realized with the use of holography. The doors have been opened for me into a new house of creation". Regarding this specific piece, the catalogue said: "Card-players, beer-drinkers, transfigured into *Les Meninas* of Velasquez, where, for the first time, thanks to holography, one can see on a plane surface the back of the canvas and also that which is represented on the face".

193

[C46]
UNTITLED. BUST OF VELÁZQUEZ TRANSFORMING ITSELF INTO THREE
TALKING FIGURES, 1974. Oil on bronze sculpture (86.50 x 64 x 39 cm)
Room 15 "Palace of the Wind"

On this bust of Velasquez, different characters of 17th-century iconography appear, with echoes of Quevedo, such as the two knights with their gorgets (eyes), the nun kneeling in prayer (nose), as well as the reconversion of the lower part of the face into a living room with armchairs and the floor, a chessboard. The primordial effect of the work, and the basic approach to Velasquez, is the image of *Las Meninas*, which appears on the painter's forehead, the oil painting that Dalí had contemplated so many times during his frequent visits to the Prado Museum in Madrid.

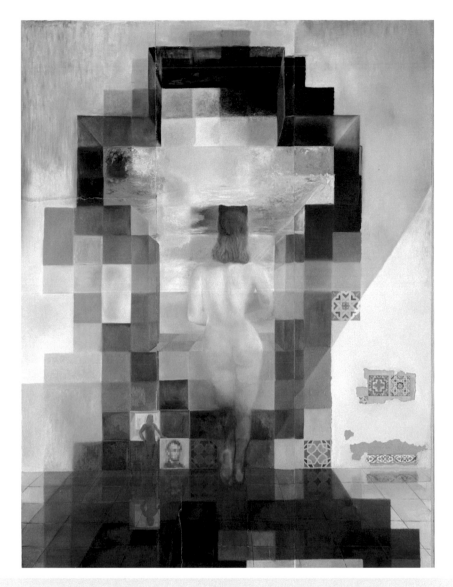

[C47]
GALA NUDE LOOKING AT THE SEA WHICH AT 18 METRES APPEARS
AS PRESIDENT LINCOLN, 1975. Oil / photography (420 x 318 cm)
Room 17 Corridor: montage

Dalí produced this work, as homage to the painter Mark Rothko, from a digital interpretation of Lincoln's face obtained by the North American cybernetic Leon D. Harmon. Once again, Dalí appears to us as an initiator and presents his concept of the double image to us in a new way. Lincoln's face is seen in small format in the lower left-hand side of the work, where the figure is also repeated, in a changed pose, of Gala. In the upper section, in a magnificent twilight, Dalí refers to his well-known oil painting *Christ of Saint John of the Cross*.

[C48]
DAWN, NOON, SUNSET AND TWILIGHT, 1979.
Oil on plywood (122 x 246 cm)
Room 20 Optical Illusions Room

An oil painting that was created from a suggestion made to the artist by the Centro Georges Pompidou to present works from the most recent period in the anthological "Dalí", held in the Paris museum from the 18th of December 1979 to the 14th of April 1980. It is a work painted with dizzy vibrations of colour applied over the surface of the work, often directly from the tube, not in a systematic way, since there are spaces that express peace and silence, and others, intense accumulation. The whole painting is perfectly linked with the shadow, in the forefront and in a slightly rising diagonal, which organises and joins the entire composition. Dalí represents the passing of time in one single piece of work, in the style of the German Altdorfer, who paints the whole development of a battle on one single canvas. Dalí reproduces the day, with the hieratic feminine figure of Millet's *Angelus*, which is repeated.

[C49]
"RAPHAELESQUE" HALLUCINATION, 1979.
Oil on panel (122 x 244 cm)
Room 20 Optical Illusions Room

Like the previous painting, he also produced this piece for the Paris anthology. It is one of Dalí's most expressive paintings with the least elements in play. He uses the base and tonal vibrations of the wood with the minimum of pictorial participation, limited to a few ochres and earthy greens, in order to create suggestions that help the spectator to discover an infinity of visual sensations: village, river, characters, fantastic landscapes and, on the right, a Raphaelesque figure, which provides the title of the work and comes from one of the characters of *Raphael's Fire in the Borgo*. It is a character that has the head of a large earthenware jar, which Dalí takes advantage of, on the same side as the recipient, to draw the line of the horizon, which is the connecting element of the whole work. It is also the only point where an intense blue intervenes, giving the sensation of water and at the same time the horizon over the sea. Over and above this, he repeats the feeling and sensation of the variety of climatic situations: of calm, peace, rain or of great luminosity.

[C50]
GALA WATCHING THE APPARITION OF PRINCE BALTASAR CARLOS, 1981.
Oil on canvas (140.50 x 100 cm)
Room 21 Tower of "All the Enigmas"

Oil painting with the presence of Prince Baltasar Carlos by Velasquez. It is a very nostalgic work, with allusions to and meanings of something that is over. It announces a tragedy to us, a premonitory work of an end that is approaching with an evanescent Gala in her setting of Portlligat, a Gala who could be the symbol of the impulse between beauty and death. A symbol of the end is the figure of Prince Baltasar Carlos, whose representation, according to Dalinian iconography, signifies death, seen from the sad history that he had to live through. The cypress tree also shares the same finality.

[C51]
THE PATH OF ENIGMA, 1981.
Oil on canvas (140 x 94 cm)
Room 5 Fishmongers' Room

Dalí donated this painting to the Theatre-Museum to celebrate his award of the Gold Medal of the Generalitat de Catalunya (Autonomous Government) in 1982, and who was present with his friend, the poet J.V. Foix. We can take in a mysterious perspective with some sacks that contain, according to Dalí, information. It is an iconography highly present in the artist's work, especially in the painting of the early period, already of a surrealist expression, *Inaugural Gooseflesh* or in the disappeared *Honey is Sweeter than Blood*. An allegorical work, its reading is based on duality, in the apparent elemental content of wheat and grain and, at the same time, the more philosophical content of information and understanding, the final meaning of the work. The painting's lines of perspective lead towards a horizon focused on a heavenly body of a cold appearance, and gives the sensation that for the same reason that there is an outward path towards an undefined background, so there is a return path, like an echo, through the double projection in the upper space.

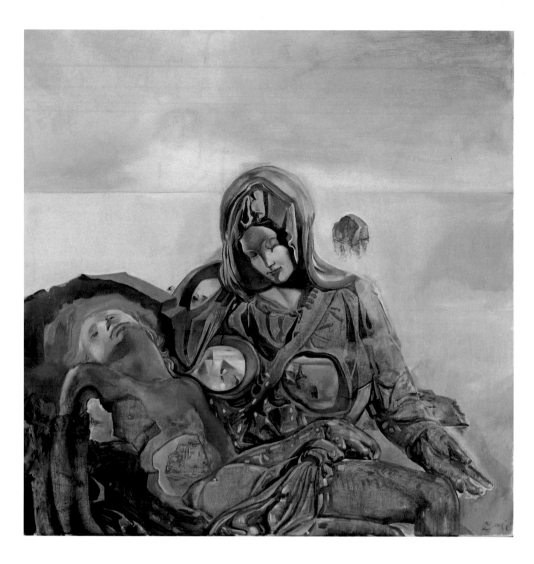

[C52]
GEOLOGICAL ECHO. LA PIETÀ, 1982.
Oil on canvas (100 x 100 cm)
Room 5 Fishmongers' Room

This work is thus titled because Dalí liked the repetition of the form of the nose of the central figure of *Michelangelo's Pieta* in the form of rocks, thus constituting an echo image. The greenish tones of the canvas, a little depressing, correspond to the period in which Gala's decline becomes clear, when Dalí's work is the result of deep melancholy and sadness on remembering the past. It was at this time when he also often used Michelangeloesque iconography.

[C53]
OTHELLO DREAMING OF VENICE, 1982.
Oil on canvas (100 x 90.50 cm)
Room 5 Fishmongers' Room

A work from the same period with the same chromatism as the previous one, which we could qualify as autumn light and which corresponds very well to the anecdotal aspect that the Venetian figure of Othello wishes to show us, in whose memories appear only a strange Venice suggested by the golden forms and tones, which for Dalí meant to look back in time, of something impossible to find again, just as occurs with past experiences. In the foreground, the presence of the rocks from Cap de Creus, in contrast with the luminosity of the dreamt Venice, has a meaning of harsh reality. Whereas the dream can be of unforeseen poetic dimensions, reality is always concentrated on tangible objects.

[C54]
UNTITLED. SWALLOW'S TAIL AND CELLOS
(CATASTROPHES SERIES), 1983. Oil on canvas (73.20 x 92.20 cm)
Room 20 Optical Illusions Room

This is the last oil painting that Dalí painted. He did it in the castle of Púbol and in this applied knowledge expressed by the mathematician René Thom in his book *Paraboles et catastrophes*. Dalí uses the form of the cello, to which he attributes symbolic functions of sentiment rather than any musical presence. In this last Dalinian period, the cello is the main subject matter, always with a painful mission; in other canvases it appears attacked by bedside tables. It is rather like a wounded ego and, in this case, it participates in the representation of a swallow's tail, the most determinant element, due to its poetic content, of all the descriptions and graphic art that he had produced in the catastrophe theory. He therefore brings these two coinciding points together: pain and beauty.

202

203

[C55]
THE ALLEGORY OF THE MEMORY, ANTONI PITXOT, 1979.
Oil on canvas (220 x 205.50 cm)
Room 12 Antoni Pitxot Room

Oil painting by Antoni Pitxot produced to occupy, just as Dalí ordered, the precise spot at the end of the corridor on the second floor of the Theatre-Museum. Pitxot's work provokes an interesting dialogue between creator and spectator. Mystery, magic, convulsive beauty and, above all, the shape of "the sumptuousness of mineral silks and velvets" are transmitted to us through an original, unique and paradoxical work. The three figures that make up the allegory of memory can be related to a passage from the *Book of Contemplation* by Ramon Llull, which describes in this way the three powers of the soul: "the first remembers what the second understands and what the third desires. The third wants what the first remembers and the second understands". This is key iconography represented in the three figures: memory, understanding and will, which interested so much the two painters, Salvador Dalí and Antoni Pitxot.

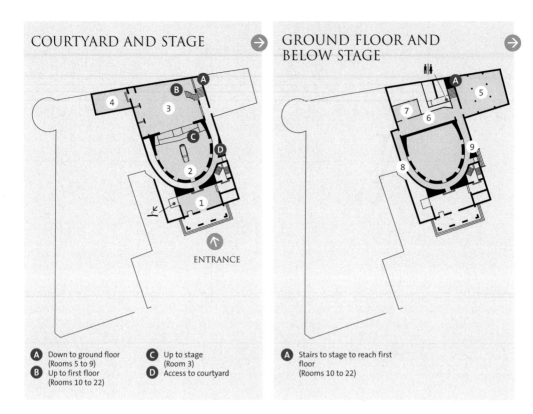

COURTYARD AND STAGE →

GROUND FLOOR AND BELOW STAGE →

ENTRANCE

A Down to ground floor (Rooms 5 to 9)
B Up to first floor (Rooms 10 to 22)
C Up to stage (Room 3)
D Access to courtyard

A Stairs to stage to reach first floor (Rooms 10 to 22)

1 Vestibule
2 Courtyard
3 Stage-Cupola
4 Treasure Room: paintings by Dalí

5 Fishmongers' Room: works by Dalí
6 "Golden Dalí" Room: work by Dalí
7 Crypt: Dalí's tomb
8 Corridor: work by Evarist Vallès
9 Corridor: montages and graphic design work by Dalí

10 Corridor: composition by Dalí
11 Mae West Room

12 Space for paintings by Antoni Pitxot, preceded by a montage by Dalí

13 "Rue Trajan" corridor: graphic design work and montages by Dalí
14 Masterpiece Room: part of Dalí's private collection of works of art

15 "Palace of the Wind" Room: work by Dalí
16 "Poetry of America" Room: work by Dalí
17 Corridor: montage
18 "Bramante's Temple" Room: montage
204 19 Loggia: optical games and stereoscopes
20 Optical Illusions Room: paintings by Dalí
21 Tower of "all the enigmas": hologram
22 "When it falls, it falls..." Room: paintings by Dalí
23 Jewels

FIRST FLOOR (FIRST PART)

→

A Up to second and third floors
(Rooms 12, 13 and 14)
B Down to exit

SECOND FLOOR

A Access to room 12
Up to third floor
(Rooms 13 and 14)

↓

FIRST FLOOR (SECOND PART)
AND EXIT AREA

←

EXIT

↓

JEWELS

THIRD FLOOR

A Access to rooms 13 and 14
Down to first floor

**FUNDACIÓ
GALA-SALVADOR DALÍ**

TRIANGLE ▼ POSTALS

Published by
FUNDACIÓ GALA-SALVADOR DALÍ
TRIANGLE POSTALS, SL

Direction
Jordi Puig

Art direction
Ricard Pla

Editorial coordination
Joan Manuel Sevillano Campalans,
FUNDACIÓ GALA-SALVADOR DALÍ
Jaume Serrat,
TRIANGLE POSTALS, SL

Text
© Antoni Pitxot,
Montse Aguer Teixidor, 2005

Photography
© Jordi Puig, 2005

Page. 15, © Català-Roca. Fundació
Gala-Salvador Dalí, Figueres, 2005
Page. 99, © Oriol Maspons. Fundació
Gala-Salvador Dali, Figueres, 2005
Page. 17, 35, 53, 69, 83, 109, 131, 141,
© Melitó Casals, "Meli". Fundació
Gala-Salvador Dalí, Figueres, 2005
Page. 15, © Xavier Miserachs.Fundació
Gala-Salvador Dalí, Figueres, 2005
Page. 75, © Parrel- Graham/
Life Magazine
Page. 97, © Enrique Sabater
Page. 29, © Studio 46, Roma

Works by Salvador Dalí
© Salvador Dalí, Fundació Gala-
Salvador Dalí, Figueres, 2005

Archive photos
Centre d'Estudis Dalinians,
Fundació Gala-Salvador Dalí

Graphic design
Joan Colomer

Layout
Vador Minobis

Translation
Steve Cedar

Supervision of contents
Centre d'Estudis Dalinians,
Fundació Gala-Salvador Dalí

Production
Imma Planas

Photomechanics
Molagraf

Printed by
Sanvergràfic
3-2010

© of edition:
FUNDACIÓ GALA-SALVADOR DALÍ
TRIANGLE POSTALS, SL

Registration number
B-31407-2005

ISBN
978-84-8478-169-1

Acknowledgements to:
Rosa Aguer, Georgina Berini,
Teresa Brugués, Maria Castellano,
Irene Civil, Maite Esteve, Carles
Font, Carles Núñez, Dai Masllovet,
Ferran Ortega, Imma Parada, Ester
Rabert, Miquel Sánchez, Joan
Manuel Sevillano

And a very special thank you to
the team at the Centre d'Estudis
Dalinians:
Sílvia Cortada, Cristina Jutge,
Rosa Maria Maurell, Mireia Roura,
Carme Ruiz

And for the valuable cooperation
of Jordi Artigas

TRIANGLE POSTALS, SL
Sant Lluís, Menorca
Tel. +34 971 15 04 51
Fax +34 971 15 18 36
www.triangle.cat